W9-BVQ-107

THE FIRST POSE

*1876: Turning Point
in American Art*

*Howard Roberts, Thomas Eakins,
and
A Century of Philadelphia Nudes*

THE FIRST POSE

1876: *Turning Point*
in American Art

Howard Roberts, Thomas Eakins,
and
A Century of Philadelphia Nudes

David Sellin

W·W·NORTON & COMPANY·INC·

NEW YORK

Copyright © 1976 by David Sellin. All rights reserved. Published simultaneously in Canada by George J. McLeod Limited, Toronto. Printed in the United States of America.

FIRST EDITION

"The First Pose: Howard Roberts, Thomas Eakins, and a Century of Philadelphia Nudes" reprinted from *Philadelphia Museum of Art Bulletin,* Spring 1975. Copyright 1975 by the Philadelphia Museum of Art.

"1876: Turning Point in American Art" was first published in the annual report of the board of trustees of the Fairmount Park Art Association. It has been slightly revised for book publication.

ISBN 0 393 04447 5 (cloth edition)
ISBN 0 393 00827 4 (paper edition)

Books That Live
The Norton imprint on a book means that in the publisher's estimation it is a book not for a single season but for the years.
W. W. Norton & Company, Inc.

1 2 3 4 5 6 7 8 9 0

1876: Turning Point in American Art

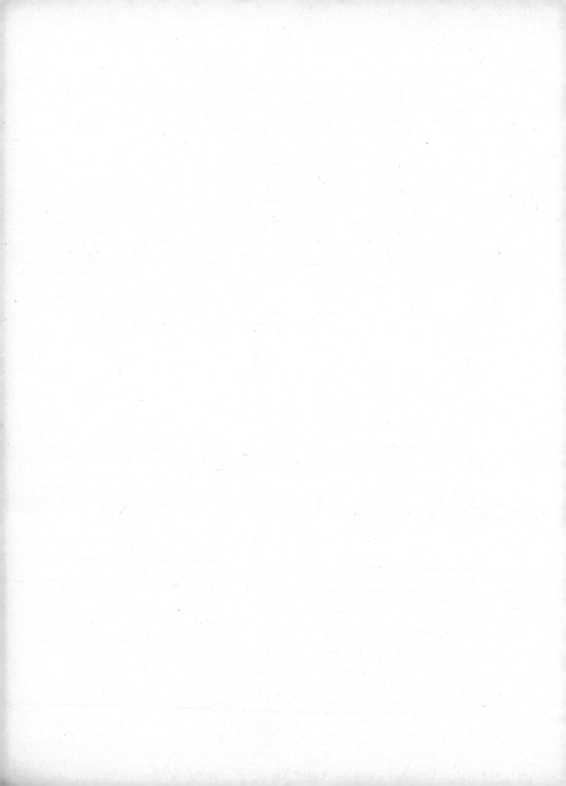

1876: Turning Point
in American Art

When Thomas Eakins and Howard Roberts returned home from Paris around 1870, Philadelphia was entering one of its periodic artistic doldrums. By then the ascendency once held by the city in the arts had long since passed to New York. The Pennsylvania Academy of the Fine Arts had sold its stately old building on Chestnut Street to a "ballet" theater, with the paradoxical result that more nudity was seen within its walls in the next few years than in the whole history of its life classes. Philadelphia's most distinguished sculptor, Joseph A. Bailly, left the country to execute important commissions in Latin America. Life classes were suspended, and there were no exhibition facilities outside of two commercial galleries, other than occasional "Art Receptions" at the Union League Clubhouse, and the display windows of Caldwell's and Bailey's & Co. Then, in 1873, there came a financial crash at a time when the snarled negotiations for the Centennial celebration held out little to indicate that in only three years' time Philadelphia would seize the lead from New York for one brilliant moment crucial in the development of American painting, sculpture, architecture, criticism, art education and museum development.

The Pennsylvania Academy of the Fine Arts had little direct part in the Centennial Exhibition. Its President, James L. Claghorn, was titular head of the Art Advisory committee, but he had his hands full funding an expensive new building in the face of defections from the ranks of those pledging financial support. Normally he left professional art matters to John Sartain, then a member of the Board of the Academy and chairman of the Exhibition, Building and School Committees, and the Academy's Secretary. Sartain wanted to play this one alone, and he stood outside the pecking order until named to the post of Chief of Bureau of the Art Department by the Centennial Commissioners, only eight months before the opening of the Exposition. Only then was it discovered that there was inadequate space provided for the number of art works expected. Frenetic activity resulted in the construction of an Annex.

The Academy's palpable contribution to the city in 1876 was the new building designed by Frank Furness, a transitional monument in the history of American art in several respects (fig. 1). In addition to being a magnificent pile in the best creative eclectic mold of the most modern variety, the great Lombardo-Gothic Eastlake basilica was to function beautifully as an art school because the expert counsel of both Eakins and Roberts was solicited in drawing up the specifications for the studios. In fact, thanks to Eakins, it became the most professional art school in the country in the decade starting with the Centennial and ending with Eakins's departure. The commission was the architect's first major building, and was awarded after a competition that he won on merit, and not through the time-honored Philadelphia device of the uncle on the Board, although he had family connections there. The Academy building was a part of an ambitious program in down-town Philadelphia at the heart of which was John McArthur's City Hall, a Louvre Pavilion shot skyward, the designs for

7

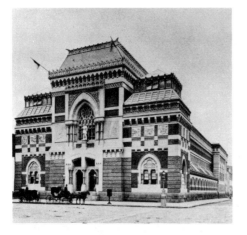

1. The Pennsylvania Academy of the Fine Arts, 1876.
Photo by F. Gutekunst. Pennsylvania Academy archives.
*Frank Furness roofed his "Byzantine or Venetian style"
basilica with glass to admit light to the school's main
studios (behind the blind arcade on the Cherry Street
side, on the north) and the exhibition galleries on the
piano nobile,* above. *The famous Greek Golden Age*
Ceres *from Megara that had stood in front of the old
building, beneath the Hawthorn tree (see fig. 6 in
"Howard Roberts") was designed into the facade
elevation—a treasure of the classic past revealed against
a medieval background.*

which won a Centennial medal but caused
French visitors to wonder why Americans re-
quired that a "petit bon-homme" perch atop
their public buildings. Nowhere in America
today is there such a harmoniously varied col-
lection of Centennial architecture in such close
proximity as on Center Square and the block
north on Broad.

In addition to its local significance, the
Academy building is a direct link to modern
architecture at its origins in the internationally
famous "Chicago School" through Louis Sul-
livan, who cut his teeth as an assistant to Fur-
ness in the project. This champion of the
dictum "Form Follows Function" went on to
father the sky-scraper, and was the mentor of
Frank Lloyd Wright. Another ingredient of
Wright's architecture that was introduced to
the American public at the Centennial was
erected by industrious little men using strange
construction methods: the pavilion of the
Land of the Rising Sun. It was comparable to
the one built at the Columbian Exposition
only seventeen years later in Chicago which
started Wright on his way to the Prairie House,
but in 1876 Japanese architecture was regarded
as bizarre. Artists and collectors were seduced
more by the ornamental vocabulary of Japa-
nese bric-a-brac than by the formal order of its
building. The time was not ripe for such dis-
coveries, but the way was being paved in
Philadelphia, where the Japanese participated
fully in an International Exposition for the
first time.

If down-town Philadelphia was being trans-
formed into a Beaux-Arts showcase, Hermann
Schwarzmann was creating a Bavarian dream
in Fairmount Park. Schwarzmann had studied
the architecture of Gottfried Semper, and had
practiced engineering in the Bavarian army,
qualifications which fitted him well for the task
of planning and erecting a temporary encamp-
ment as monumental as the 1876 Exposition.
In Philadelphia he had landscaped the Zoo,
many small structures in a picturesque park
setting, which probably conditioned his Cen-
tennial solution, for he rejected the one used
since the days of the Crystal Palace: one vast
structure to house official exhibits, like the one
he saw in Vienna in 1873 and found wanting.
His innovation of many buildings within a
controlled environment has been adopted in
World Fairs ever since—another first for Phila-
delphia in 1876. Perhaps a last was James H.
Windrim's U.S. Government building going
up in a matter of weeks, completed ahead of
schedule and far under the budget. *Staff*, the
ephemeral plaster concoction which made the
superficial embellishment of the Great White
City possible in 1893, was not yet in use, so the
temporary buildings challenged the ingenuity
of the architects, who produced a delightful
variety, running the gamut from purely func-
tional design in iron and glass to stick-style
confections (fig. 2).

Schwarzmann's Memorial Hall was of dura-
ble material, as befitted the permanent home
of the city's newly incorporated museum of art
(fig. 3). Boston and New York had just inaugu-
rated art museums so Philadelphia's was not
the first, but it was certainly the grandest. If
City Hall is Louis XIV, Memorial Hall is Lud-
wig I. Mrs. W. P. Wilstach's express admira-
tion for the Dresden Museum, designed by
Semper, might well have conditioned the Ger-

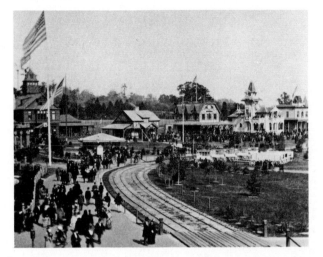

2. The Centennial Fairgrounds on New Hampshire Day, October 12, 1876. Centennial Photographic Co.; collection of the author. *The state pavilions are an index of current popular taste in architecture of a domestic scale. Left to right, they are Massachusetts, Connecticut (with brownstone arch beside it), New Hampshire, Michigan, and Wisconsin. The Michigan building, constructed entirely of native woods, was considered one of the most artistic state buildings on the grounds.*

man Renaissance form.* The arcades of the hyphens were then open, screening parterres designed for sculpture. The great rotunda remains one of the grandest of its kind in this country.

In his Bureau Chief's report John Sartain said that no department of the Centennial had been as popular as the art exhibition. Sculpture of the virtuoso "Barochismo" that had newly replaced Neoclassicism filled the Italian section, which was crowded with admirers at all times. Originals and duplicates were bought by the dozens. Thus the infant Benjamin Franklin and George Washington—*Franklin and His Whistle* and *Washington and. His Hatchet*—came to occupy both the Union League Club and the Evans Art and Dental Museum of the University of Pennsylvania, and Barzaghi's *Finding of the Infant Moses,* one of the most popular of the Italian exhibits, was purchased for the Pennsylvania Academy of the Fine Arts.**The day of Neoclassical sculpture was over.

* The Wilstach bequest, including the collection, was the basis for founding the Pennsylvania Museum, now the Philadelphia Museum of Art, and the construction of Memorial Hall.
** The anecdote of Franklin is on a par with Parson Weems's tale intended by the sculptor for the American popular trade. Both are by Pasquale Romanelli of Florence. Francesco Barzaghi's *Moses* was on a higher plane, a Milanese tour de force of cutting and texture.

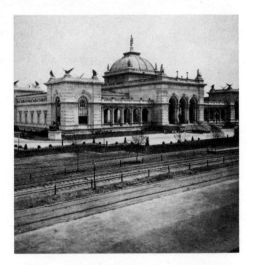

3. Memorial Hall: The Art Gallery of the Exhibition, 1876. The Centennial Photographic Co.; Smithsonian Institution. *Hermann Schwarzmann designed his "modern Renaissance style" art gallery as a permanent structure for the Pennsylvania Art Museum and School of Industrial Art, newly founded on London's South Kensington system. Today they function separately as the Philadelphia Museum, and the College of Art. The picture was taken about May 1, before the opening, but after Larkin Mead's Navy Group for his Lincoln Monument in Springfield, Illinois had been put in place at the corner (an exhibition of the Ames Mfg. Co. of Chicopee, Mass.).*

9

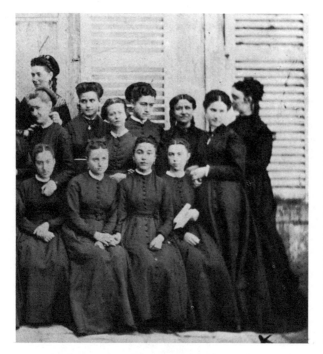

4. Painting Class in Paris, 1868; detail. Pennsylvania Academy archives. *In this photograph, sent by Eliza Haldeman to her family, Mary Cassatt is the tall girl at the rear, and Eliza at the far right. Her sex barred Cassatt from her intended course at the École des Beaux-Arts, and a visit to Barbizon decided her against following Millet. In Paris she enrolled in the private ateliers of the painters Soyer and Chaplin, and at Ecouen with Frere. She copied in the Louvre with Eliza in 1867, and exhibited at the Salon of 1868 under the name of Mary Stevenson. She did not exhibit at the Centennial, but two years later contributed to the landmark exhibit of the Society of American Artists.*

Since the Revolution progressive artists in Philadelphia had been oriented to France, not to England. The great French sculptor Houdon had selected the Academy casts, and the first professor of painting, drawing and study from the Antique, appointed in 1812, was a French emigré trained in the Vien/David mode of Neoclassicism, Denis A. Volozan. Internecine struggles among artists and between artists and the lay management brought things to a stand-still by 1824 and the school was all but defunct. When the school was resuscitated in 1855, both chief instructors once again were Frenchmen: Christian Schussele and Joseph A. Bailly. Paris-trained emigrés from the strife of 1848, they found their separate ways to Philadelphia. The moribund body of Pennsylvania Academicians was revived by Peter Rothermel and Sartain as an instrument with which to wrest control of the professional aspects of the Academy from the businessmen on the Board. By charter it governed the exhibits and schools. Soon Schussele and Bailly were members of its Council

with Sartain, Rothermel, Samuel B. Waugh and others, all of whom offered criticism to the students. In the early days Rothermel was most active, but by the time of Thomas Eakins, Mary Cassatt, Earl Shinn, William J. Clark, Howard Roberts, and William Sartain, the main burden of instruction fell on the Frenchmen, who offered as good a classical background as was available at the time in most French art schools outside of Paris. Naturally, their students were oriented towards the newly overhauled Imperial School of Fine Arts in Paris, the École des Beaux-Arts.

To improve the tarnished image of the Pennsylvania Academicians John Sartain engraved a splendid diploma and went abroad with his daughter Emily in 1862 to distribute it (honoris causa) to everyone in high position in art schools of Europe and the British Isles. John Ruskin became a Pennsylvania Academician, and also Albert Lenoir, permanent Secretary of the École Imperiale des Beaux-Arts. While in Paris Sartain paid a visit to Daniel Ridgway Knight, an Academy alumnus

who found copying in the Louvre in winter a chilly affair. Sick, and fearing a rebel invasion of Philadelphia, Knight returned home, bringing with him tales of Alfred Sisley, Renoir, and other friends to the Academy, where he painted alongside Eakins and Cassatt.

Meanwhile, students and alumni of the Academy had founded the Philadelphia Sketch Club, which was to become of vital importance to the arts in Philadelphia for a score of years. A few weeks after it was chartered the Civil War broke out, but it continued to function with Earl Shinn, Knight, Robert Wylie and Charles F. Haseltine holding the fort as officers, and culminated the war years with the tragedy of a member, Edward McIlhenny, buying himself out of conscription the day before Appomattox. Robert Wylie was Curator of the Academy, living there on the premises, supervising the coming and going of art works, models and students. Young, gentle and well liked, he was a sculptor and showed reliefs in ivory and other materials in the Academy's Annual Exhibitions. Soon after Knight came home Wylie sailed for France with introductions from him to Sisley and other friends. He studied briefly with Barye at the Jardin des Plantes, and with Gérôme, but soon retired to Pont-Aven in Brittany, painting strong and unconventional pictures which excited admiration both from Salon judges and admirers of Courbet (fig. 5). Academy students sought him out there when they came to France, and an American community gathered around him in Pont-Aven twenty years before Gauguin and his entourage made the name of the place celebrated to all students of modern art.

In April 1866, the war over, Earl Shinn and Howard Roberts sailed together for France. In July they applied through the U.S. embassy for admission to the Beaux-Arts, and then went off to Point-Aven to paint with Wylie, Frederick A. Bridgman, Benjamin Champney and other Americans. After repeated application to the École, American Minister John Bigelow despaired of their gaining admission—there was no room in the studios, according to Count Nieuwerkerke. None of the Philadelphia applicants knew French. Roberts happened on Champney in Paris in October 1866 when the Bostonian was on his way home, and Champney took him on a tour of sculptors' studios, settling him finally with Guméry; Shinn was still afloat. Mean-

5. Robert Wylie, *Breton Fortune Teller*, 1872. Corcoran Gallery of Art, Washington, D.C. *Wylie was the curator of the Pennsylvania Academy before going to France towards the end of the Civil War to study with Barye, Couture, and Gérome. He settled in Pont-Aven by 1866. Among young Americans who benefited from his kindness and instruction were Earl Shinn, Howard Roberts, William Sartain, Thomas Eakins, Thomas Hovenden, Frederick Bridgman, William L. Picknell, Augustus St. Gaudens, and J. Alden Weir. This painting won him a medal at the Salon of 1872. Acting on his advice, W. P. Wilstach bought the best Salon art each season for the collection that became the matrix of the Philadelphia Museum of Art.*

while, back in Philadelphia, with four years of Academy study behind him, Eakins swam and watched the fire-flies in the Wissahickon, and played word games with his friends Emily and William Sartain in Latin, Italian and French. In September he got a letter in response to inquiries made of Albert Lenoir, Pennsylvania Academician, about entering the École, and took the next direct steamer to France, only to find himself, on arrival, in the same situation as his friends. For the second year in a row no Americans had been admitted, and Bigelow and John Hay washed their hands of it. Unlike the others Eakins knew French, and he had a primitive American instinct about authority that got him past flunkies and porters. Feigning ignorance and deafness he barged into Nieuwerkerke's office, and for a half hour waxed so eloquent in French that the entire slate of American applicants was admitted to regular status, including Eakins, Shinn, Roberts, Bridgman, and, soon afterwards, three other Philadelphians, Humphrey Moore and William Sartain, close friends of Eakins, and the Sketch Clubber Howard Helmick. All owed their good fortune to Eakins, but all were sufficiently prepared by their provincial French Academy in Philadelphia (all but Bridgman, a bank-note engraver) that Americans were welcomed for years to come—all male Americans, that is.

Mary Cassatt had attended all the regular Academy offerings in the same four years as Eakins, and she copied in the Academy galleries with her friend Eliza Haldeman. Provincial it might have been, but the Academy was one of the most liberal art schools in the world with regard to admission of women. Mary Cassatt aspired to return to the Paris she'd known in childhood, but when she got there it was to find herself excluded from the École des Beaux-Arts. In the studio woman's place was on the model stand, at it was in England, where it was dictated more by prudery than misogyny; in Zoffany's famous picture of *Royal Academicians in the Life Studio* the two female members are admitted only as paintings on the wall. In France art was considered beyond the intelligence of women. Those with the perseverance to find their own education, and the talent to succeed, were accepted as equals. Mary Cassatt enrolled in the private studios of Chaplin and Soyer,

and received private criticism from Gérôme, went on out-door sketching trips with Eliza, and with her copied the masters in the Louvre. The two girls thus engaged in Winslow Homer's *Copyists in the Louvre* I believe are Mary Cassatt and Eliza Haldeman, caught in the act by the roving reporter from *Harper's* (fig. 6).

Mary Cassatt was the only American accepted into the group called Impressionists, since Knight had taken another route that led him to Poissy and the tutelage of Meissonier. Her first success began with an acceptance in the Salon of 1868 under her family name of Mary Stevenson, not an uncommon safeguard for young ladies fearing unfavorable criticism in artistic debuts. (Eliza Haldeman was also exhibited.) In 1872 she began exhibiting under her own name in France. By 1876 she was well on the way towards earning a reputation in New York as a *Realist!* Her mature painting is bathed with the indoor light of loge and conservatory like that of her friend Degas, an Impressionist by alliance rather than by definition. The calligraphy that fills the picture plane of the Philadelphia Museum's double portrait of Mary Cassatt's brother and his son is close to the freest work of Degas, an interesting example of the paradox inherent in the ideology which abolishes black from the tube but recreates it so well with umber and ultramarine mixed on the palette. It is the antithesis of the academic standard of her fellow Philadelphian Eakins, for whom omitting black was like playing music with no base notes. Cassatt did not send to the Centennial, feeling perhaps like J. Alder Weir that she was not ready and regretting it later.

The revolutionary Americans to show in the Centennial were just emerging into maturity after years of study in the academies of Paris and Munich. Important *French* works were created for the exhibition by Thomas Eakins and Howard Roberts, both masterpieces in the old sense of the word: *The Gross Clinic* and the *Première Pose*. The *Court Jester: Keying Up* by William Merritt Chase is a Bavarian blend of "brown sauce" and Frans Hals, although Chase considered it in the tradition of Velasquez (fig. 7). This great Spaniard was a fundamental influence on Eakins's *Gross Clinic,* so even in their diversity the two new American schools found some unity, not the

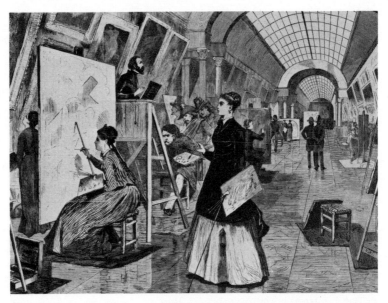

6. Winslow Homer, *Art Students and Copyists in the Louvre.* Harper's Weekly, *January 11, 1868. Homer was in Paris for the Exposition Internationale of 1867, where his* Prisoners From the Front *was shown. In this illustration sent back to* Harper's *he may well have caught Mary Cassatt and Eliza Haldeman in their studies. Homer was represented in the Centennial by four paintings, including his* Snap-the-Whip.

least of all in a new professionalism. Both the Paris and Munich Americans seemed a threat to the Old Guard National Academicians, who acted to protect themselves from being overrun on their own home ground by these artists of the "New Movement," but in a manner so blatantly self-serving that they accomplished the reverse of their intention. They caused the new apostles of Gérôme and Bonnat, on the one hand, and on the other Piloty and Leibl, to unite into a new association called the Society of American Artists. At its first exhibition in 1878 the stamp of Paris and Munich was visible to all. Soon the flashy brush-work of Munich prevailed in New York, while Philadelphia continued to favor the in-

7. William Merritt Chase. *The Court Jester: Keying Up,* 1875. Pennsylvania Academy of the Fine Arts. *Chase mastered in Munich the free brush work that was so admired there by the artists around Wilhelm Leibl. With the removal of the great art collections from Dusseldorf to Munich, and under Bavarian royal patronage, Munich had replaced Dusseldorf as the German art center by 1870, when it became the major alternative to Paris for Americans seeking instruction in art abroad. The* Jester *was shown in the "Saloon of Honor" of the United States exhibit in the Centennial Art Gallery.*

tellectual and technical problems of the Beaux-Arts, a very different French allegiance than that which Boston had formed with Barbizon and Couture through William Morris Hunt. These tendencies were formally proclaimed after the Centennial by the appointment of Chase and Eakins to the faculties of the New York Art Students' League and the new Pennsylvania Academy of the Fine Arts, respectively.

At the Centennial it was the Beaux-Arts students who had the lead. Bridgman and Moore were medalled for their contributions, and Eakins was well represented by six works in the art galleries. Howard Roberts stole the show with his *Première Pose,* an example of what the French call an *académie,* a close and accurate study from the nude model intended to show the complete command of the subject and materials, with no more narrative than necessary to make the work plausible. Roberts took as his subject a model posing nude for an artist for the first time; Eakins would turn to the same subject in his painting of *Rush Carving the Schuylkill.* William Clark, an officer of the Sketch Club and critic for the *Telegraph,* said that Roberts's work was as much an extension of the French exhibit as a part of the American. In retrospect Lorado Taft said that beside the *Première Pose* all earlier American sculpture resembled poor taxidermy, and that from this time on the sculptor must know his theme. He saw Roberts as transitional between Hiram Powers and St. Gaudens. While Roberts was back in Paris working on the *Première Pose,* St. Gaudens had just completed his own stint in the Beaux-Arts and was in Rome working on his own *académie,* a *Hiawatha* that shows he had reached about the same point of transition in his own development from, say, Thomas Crawford to his later work. But at that point in the evolution of American art as a whole Roberts's achievement was the most advanced of its kind, and represents the key example of a stage through which it had to pass in going from the Italianate Neoclassicism, best represented in 1876 by the *Jerusalem* of W. W. Story, into the predominantly French productions of the new era.

The masterpiece that Eakins painted for the Centennial was rejected by the Committee on Selection, and the only conclusion that can be reached is that it was a victim of the New York Old Guard: Hicks, Huntington and Whittridge. John Sartain thought the painting a "capital work," but he was not on any of the juries, and in fact antagonized them by blithely ignoring their responsibility time and time again. Bostonians would not have objected to the new French Realism, and the Philadelphians on the Committee were Howard Roberts, ex officio as President of the Sketch Club, and Eakins's old friend Samuel Bell Waugh. The New Yorkers demonstrated their hostility to the *Gross Clinic* when it resurfaced in their city in 1879, and they spent most of their time in 1876 bickering with Sartain. The day after local summissions were presented to the Committee as a whole, the *Gross Clinic* was put on public exhibition at the gallery of the old Sketch Clubber Charles F. Haseltine, apparently rejected from the Centennial art exhibition. Clark saw it and proclaimed it a work of great learning, and said that nothing greater had ever been painted in America. The blood on Gross's hand was said to have sickened some of the older jury members, he said, but he proposed instead that what had sickened them was the appearance of a new talent greater than their own.

Nonetheless, the *Gross Clinic* did appear at the Centennial and in a context appropriate to its subject. The U.S. Government had stated its desire to exhibit portraits of distinguished citizens in appropriate departments, and the *Manual of Military Surgery* compiled by Gross had been used by both sides during the Civil War and was still used on the frontier. The distinguished surgeon was the author of the standard text on his subject, had just completed a Centennial history of American Medicine, and was the President of the medical congress held in Philadelphia in 1876. No more appropriate place could have been found for it, nor any more appropriate portrait, than among the pathological exhibits in the prefabricated U.S. Army Post Hospital, where it was lent by Dr. Gross himself (see fig. 30 in "The First Pose").

I believe that it still stands as the greatest single painting in the history of American art.

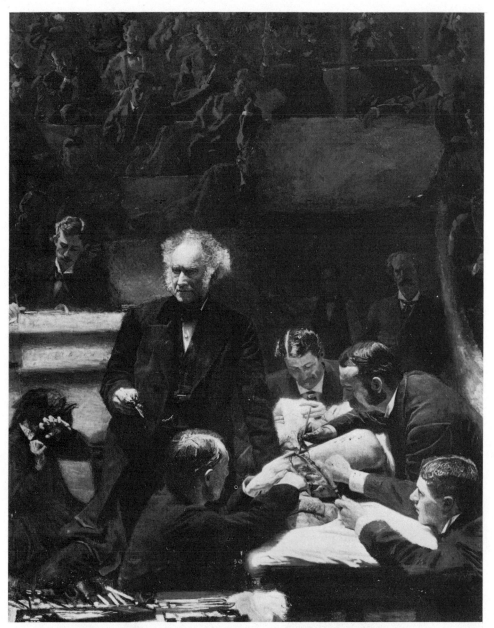

8. Thomas Eakins, *The Gross Clinic*, 1875. Thomas Jefferson University, Philadelphia.
*Eakins was well represented with six paintings at the Centennial, but the masterpiece he
painted for it was rejected by the art jury and ended up as part of the United States Army
Post Hospital Exhibit (see below, fig. 30 in "Howard Roberts").*

15

It represents a great surgeon, but more than that it is an allegory of the triumph of American science, a tribute to the major medical contribution to suffering humanity, the discovery of the anesthesic quality of ether. At the same time it is a part of a long tradition of medical iconography going back through Golzius and Jan Stefan von Calcar to the Renaissance founder of modern anatomical research, Vesalius. A work of Realism in the French manner of Gérôme and Bonnat, it is also a testimonial to the new Experimental Method of the Naturalists, and a black-on-black painting that engages Art for Art on its own ground. It is indeed a work of great learning, and one which reinterprets the achievements of the great Baroque masters Velasquez and Rembrandt without being damaged in comparison.

In 1876 Eakins went as an unpaid assistant to the Pennsylvania Academy and brought that learning to bear on his teaching. For several years he had run classes at the Philadelphia Sketch Club, and he came to the Academy with his students on their petition.

In the next ten years he made the school one of the most thorough of its kind in the world, teaching the tools of the trade without imposing conventions. There was, as Alexander Stirling Calder recalled, a spirit of Walt Whitman in the air. My favorite manifesto of American Realism, or Naturalism, is a photograph taken some time about 1890 and published by *McClure's* as *A Consultation in the Studio* (fig. 9). The studio is Eakins's own on Chestnut Street, full of the confusion of the work room—clay barrels and model stands, anatomical casts made in the dissecting room, and none of the fashionable Beaux-Arts bric-a-brac. William O'Donovan sits in animated conversation with Eakins, and photographs of Walt Whitman are fixed to the wall behind O'Donovan's bust of the Gray Bard. Perched convivially among the glasses and bottles on the table is Winslow Homer in an effigy made by O'Donovan and owned by Eakins (collection of the Pennsylvania Academy of the Fine Arts).

So this turning point in American art was effected in Philadelphia in 1876 by a group

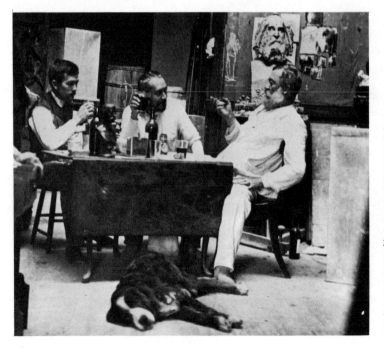

9. *A Consultation in the Studio*, ca. 1890. Philadelphia Museum of Art. *Samuel Murray, Thomas Eakins, William O'Donovan, and Harry (reclining) in Eakins's Chestnut Street studio. Eakins's photos of Walt Whitman are pinned to the wall at the right behind the bust of the poet by O'Donovan, whose portrait of Winslow Homer is on the table among the bottles. The bust of Homer belonged to Eakins, who presented it to the Pennsylvania Academy, which also owns Eakins's portrait of Whitman.*

16

of distinguished native or adoptive Philadelphians: Eakins, Roberts, Furness, Schwarzmann and Shinn. Shinn gave up serious painting on finding his vision was not what it might be and turned to art criticism. Some of his "center table" editions were pot-boilers, but his serious efforts produced some of the most responsible criticism of the Centennial period and of the Exposition itself. In Paris he had listened with Eakins to the Naturalist discourses of Hippolyte Taine, and he sent back "penny a liners" to the *Bulletin*. On returning to America he determined to bring to his criticism the approach of Taine, then novel in this country: the study of the character and the surrounding circumstances of a work of art, the disinterested classification of works of art into species and genus, and the analysis of the conditioning environment, as in biology. He did this in his articles for the *Nation, Harper's, Scribners, Lippincott's,* and several newspapers, under his own name and pseudonyms lke Edward Strahan, Sigma, E. S., Philadelphiensis, L'Enfant Perdu, and others. On the opening of the new Academy he offered a series of critical lectures along the principles of Taine. This was the new, informed but objective criticism, as opposed to the doctrinaire criticism of Clarence Cook, whom Shinn considered a "Pre-Raphaelite prig."

Meanwhile, standing in the wings were Mary Cassatt, Robert Wylie and William Sartain, not participants in the Centennial itself, but already involved in 1876 in activities fundamental to outgrowth in the arts in the decades to follow. Wylie was Wilstach's adviser, and he saw to it that the most notable Salon paintings were acquired; because of him the new Museum of Art in Memorial Hall came to house a most distinguished collection of art recently judged the best in Paris. New York came to benefit most from Mary Cassatt's expertise through the Havemeyer collection,

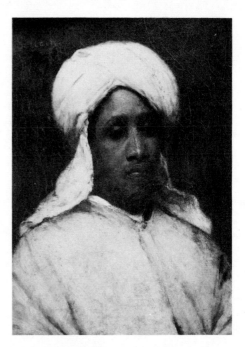

10. William Sartain, *Nubian Sheik,* 1875. National Collection, France. *A fellow student of Eakins in Philadelphia and Paris, Sartain's father was Chief of Bureau of the Art Department of the Centennial, which probably led to his rejection or exclusion from the exhibition. At the simultaneous exhibition marking the opening of the new Pennsylvania Academy of the Fine Arts he exhibited this beautiful head, sometimes called* Bedouin Chieftain.

but she also conditioned Philadelphia collectors. Thus, for a time it was possible to see in Philadelphia the best Impressionists against the foil of the best contemporaneous academic artists, before the Wilstach Collection's dispersal by the Philadelphia Museum and shortsighted de-accessioning by the Academy only twenty years ago.

Howard Roberts, Thomas Eakins,
and
A Century of Philadelphia Nudes

Howard Roberts, Thomas Eakins,
and
A Century of Philadelphia Nudes

The Birth and Death of an Academic
Tradition: Nudes and Prudes in Philadelphia
(1795–1830)

"How like it is to a young Mohawk warrior!" exclaimed Benjamin West on seeing the Apollo Belvedere. But what ran through his mind on first seeing the Capitoline Venus? There had not even been a cast from the Antique in Philadelphia to prepare him for what he saw in Rome, and in his native Pennsylvania, Indian women were as puritanical about nudity as the settlers. Only after he was long gone from Philadelphia did Aphrodite arrive in a "plastic condition" at the "Athens of the Western World." Philadelphia morality was undiluted by the wreckage of French society soon to wash ashore in the wake of that other Revolution when Robert Edge Pine came to the city from England in 1783 to paint the portraits of American patriots, as Judge Joseph Hopkinson recalled fifty years later, when president of the Pennsylvania Academy:

I remember his arrival in this country; he brought letters of introduction to my father, whose portrait was the first he painted in America. . . .

He brought with him a plaster cast of the Venus de Medicis, which was kept *shut up in a*

The author extends special thanks to Dr. H. Radclyffe Roberts and Mrs. Evan Randolph for directing him to valuable original material, and to Dr. Lois Fink, Mr. Richard Murray, Dr. Michael Richman, and Mr. Marchal E. Landgren for their comments and expertise. This study was completed under a research grant from the National Collection of Fine Arts, Smithsonian Institution.

case, and only shown to persons who particularly wished to see it; as the manners of our country, *at that time,* would not tolerate a public exhibition of such a figure. This fact shows our progress in civilization and the arts.[1]

Early attempts by William Rush, Charles Willson Peale, and Giuseppe Ceracchi to set up a "Life Academy" foundered on personalities, but out of meetings at Peale's Museum, then at Third and Lombard streets, there emerged late in 1794 a union of artists dedicated to the promotion of the fine arts and the establishment of a proper academy. "This infant academy had but meagre equipment," an anonymous historian wrote. "The cast of the Venus de Medici was resurrected from the surrounding mass of rubbish in which it had been left by the family of Pine. . . . This cast and a composition figure given by James Trenchard and a few battered antiques, were the only models which the students of the school had to draw from."[2] Calculations for budgeting a life class scribbled on the reverse of minutes of a meeting attended by both Rush and Peale on April 20, 1795, show that more than an Antique class was intended:

Suppose that ½ Cord of Hiccory wood @ 5.00
6 doz. of Candles. 1.20
Oil ½ galln. .50
Figure at a Dollar each night. 5.00
 11.70
Suppose the pupils to 12, the cost per week, 1.00[3]

In Philadelphia there was no Piazza di Spagna where models congregated for the privilege of posing, so the first class problem was to find a model. "A young baker, who had been observed to be finely proportioned as he labored,

stripped to the waist, at his ovens, was engaged as a model," writes Charles Coleman Sellers. "The young baker, however, finding that his torso was to be the object of general study and attention, donned his jacket and fled in panic at the thought."[4] And so Peale, "finding nobody who would exhibit his person for hire to the students, whipped off his frills and ruffles and bared his own handsome torso for the class."[5]

The Columbianum, as this association was called, had a meteoric success but died within a year. "I endeavored for some time to keep it alive, as a tender, beautiful plant," Peale wrote Thomas Jefferson,[6] but the climate was not right. In 1805, ten years after the Columbianum failed, he told Jefferson of a projected academy, where "the living model school will be opened at proper seasons,"[7] and this time he took the precaution of having his son Rembrandt draw up the plans prior to the first meeting. From this second campaign the Pennsylvania Academy of the Fine Arts was born. Pine's Medici Venus had served valiantly in hostile territory, but was retired on the arrival in Philadelphia of the Bonaparte casts, selected by Houdon from among the casts made in the Louvre from the spoils gathered by Napoleon, and sent with the best wishes of the Emperor to the new Pennsylvania Academy. They were installed in 1807, but not without controversy:

A species of modesty as it is called, or of prudery or mock modesty as we certainly shall call it, has given abroad an idea of indelicacy, in the exhibition of models of the human figure in chalk or gypsum! Surely this pharasaical spirit cannot belong to a time when the common apparel of our females leaves so little for the imagination—The statues are in fact partitioned off, and you see here and there the head of a *fawn,* apparently splitting his sides in the *back ground,* at the false delicacy which consigns so many of the ancients to *shades and darkness,* while so many of the *moderns* are moving about in a state of transparency approaching to nudity.[8]

About the time that Hopkinson congratulated his city on its progress in the arts since the days of Pine, Mrs. Trollope came to Philadelphia, and after a visit to the galleries of the Pennsylvania Academy offered a few of her own ideas on the subject. "Perhaps the arrangements for the exhibition of this room, the feelings which have led to them, and the result

they have produced," she wrote, "furnish as good a specimen of the kind of delicacy on which the Americans pride themselves, and the peculiarities arising from it, as can be found":

One of the rooms of the Academy has inscribed over its door, ANTIQUE STATUE GALLERY. The door was open, but just within it was a screen, which prevented any objects in the room from being seen from without. Upon my pausing to read this inscription, an old woman who appeared to officiate as guardian of the gallery, bustled up, and addressing me with an air of much mystery, said, "Now, ma'am, now; this is just the time for you—nobody can see you—make haste."

I stared at her with unfeigned surprise, and disengaging my arm, which she had taken apparently to hasten my movements, I very gravely asked her meaning.

"Only ma'am, that the ladies like to go into that room by themselves, when there be no gentlemen watching them."

On entering this mysterious apartment, the first thing I remarked, was a written paper, deprecating the disgusting depravity which had led some of the visitors to mark and deface the casts in a most indecent and shameless manner. This abomination has unquestionably been occasioned by the coarse-minded custom which sends alternate groups of males and females into the room. Were the antique gallery thrown open to mixed parties of ladies and gentlemen, it would soon cease. Till America has reached the degree of refinement which permits of this, the antique casts should not be exhibited to ladies at all. I never felt my delicacy shocked at the Louvre. . . .[9]

The Academy certainly exercised a healthy influence through its handsome building, collections, and exhibitions, but with regard to the study of the nude, progress in its first decades can be measured only in scale. Ladies Day at the Gypsothèque replaced the furtive peep into Pine's cabinet, and as for the "living model school" two were established at the Academy, working at cross purposes. Peale and Rush, both members of the Board of Directors, had little success with their project until the management found Academy supremacy threatened by the Society of Artists, a new group composed largely of the dissidents who had caused the downfall of the old Columbianum. By charter the Academy could not deny the use of its premises to the Society, but to counter its influence, the Academy founded an honorific body of its own, the Pennsylvania Academicians, or P.A.'s, to which it named the

most distinguished members of the rival Society. Forty Pennsylvania Academicians were given the responsibility of regulating Academy schools and appointing professors, and had representation (without vote) on the Academy Board. By charter the Pennsylvania Academicians was dominated by painters, unlike the Society of Artists, so practitioners of reproductive engraving and allied crafts could not band together with graphic artists to gain control. The Society of Artists and the Pennsylvania Academicians announced the opening of courses at about the same time, those of the Society of Artists taught principally by Denis A. Volozan, a French émigré with solid training in the classical style of David. The Pennsylvania Academicians announced that it had founded a Life Academy, bought equipment, and "made this Academy equal in every respect to any Institution of the kind in Europe, except in the size of the Room, which in a few years will probably be found too small. . . . the Life Academy will be the foundation of the Historic Art in this Country."[10] Volozan had been named to the original body of Academicians and was now engaged to teach this Life Academy.

To enhance the Academicians' image the Pennsylvania Academy awarded diplomas to its membership, in exchange for which the recipient was to donate a work of his to the Academy, but with an unfortunate result:

> At some public meeting, where ladies were invited, each academician received, with great pomp and ceremony, a paper tied with a pink riband, which were thought to be the diplomas, until they reached home and went to exhibit the honours conferred upon them to their families and friends; when, lo! to their disappointment and chagrin, each had a piece of *blank paper!* I believe this was the death blow to all zeal on the part of artists of that day. . . .
> When the artists complained of the trick played off upon their credulity, they were promised soon *"righty dighty"* ones, but to this day no one has ever been thus honoured by the board.[11]

According to Dunlap, "the consequence of a want of union, between those who held the purse and those who possessed the knowledge, was, that the schools languished and failed."[12] The Society of Artists was the first to fade, and with the threat gone the Academy management neglected its own Academicians. By 1828 relations between the directors and the artists had so deteriorated that a grievance committee composed of John Neagle and James B. Longacre was appointed by the Academicians' membership to request the courtesies it had been led to expect, and to ask for the return of the life studio, which far from proving too small had functioned as such for a scant dozen years. Joseph Hopkinson, an Academy founder, and witness to Pine's arrival in 1783, replied for the directors:

> It was represented to the directors that to complete our system of instruction, and afford our artists the highest benefits which an academy can bestow upon them, it was necessary to have a *Life School.* Immediately the north-east room below stairs was appropriated to this object. It was fitted up and arranged at an expense of several hundred dollars. The Academy assumed the whole charge of warming and lighting the room and providing models to draw from. These amounted to an annual expense of about three hundred dollars. The life academy opened with great spirit. About fifteen artists attended to take advantage of it, and the directors were pleased, and proud of the success of the experiment. The artists after a time got tired: they began to drop off one by one, until but three were left, of whom Mr. Sully was one. . . . The apartment then became a lumber-room, and no artist has ever asked for the use of it from that time to this.[13]

Was this the progress in civilization and the arts Hopkinson had reported? Was the season Peale predicted to Jefferson to be so short? The state of study of the human figure from life at that time is transmitted in an anecdote which might have originated in the plight of William Rush, who was old but still active at the time of Dame Trollope's visit to Philadelphia:

> The entire absence of every means of improvement, and effectual study, is unquestionably the cause why those who manifest this devotion cannot advance farther. I heard of one young artist, whose circumstances did not permit his going to Europe, but who being nevertheless determined that his studies should, as nearly as possible, resemble those of the European academies, was about to commence drawing the human figure, for which purpose he had provided himself with a thin silk dress, in which to clothe his models, as no one of any station, he said, could be found who would submit to sit as a model without clothing.[14]

23

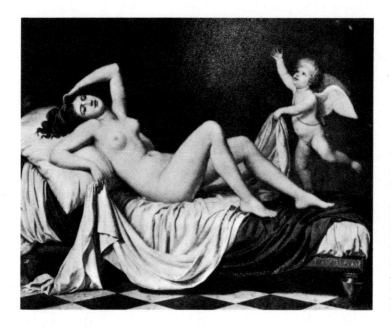

1. Adolph-Ulrich Wert-
müller (born Stockholm
1751; died Wilmington,
Delaware, 1811). *Danaë
and the Shower of Gold*,
1787. Oil on canvas,
59¹⁄₁₆ × 74¹³⁄₁₆″.
Nationalmuseum, Stock-
holm. Given by Mr. J. E.
Heaton, 1913. *Philadel-
phia's first exhibition
nude arrived in the city
with its painter in 1795,
and both were met at the
dock by Charles Willson
Peale, who helped them
through customs.*

Exhibition versus Exhibitionism
in Philadelphia (1795–1814)

If it was difficult to find a model who would
pose naked, this was matched by the scarcity
of any naked effigy. Engravings after Rubens
served Philadelphia artists, such as Henry Ben-
bridge, for instance, but there were few paint-
ings. The first painter to challenge the Phila-
delphia taboo against "exhibition figures" was
the Swede Adolph-Ulrich Wertmüller, whose
Danaë (fig. 1) holds a position akin to Pine's
Venus in the history of American painting.
The arrival of the artist and his painting in
Philadelphia early in 1795 was etched in the
memory of Rembrandt Peale:

> Dissatisfied with the unsettled state of Europe,
> Wertmüller came to Philadelphia in the year
> 1795. He had been painter to the King of Sweden
> and had gained some celebrity by Pictures of
> Poetical and Mythological subjects, his most re-
> cent one being a *Danaë*. Our custom-house then
> made no distinction in favor of the arts and Mr.
> Wertmüller found himself embarrassed by the
> excessive charges of duty on his Paintings. In this
> dilemma he was advised to apply to my father
> and me, and we succeeded in getting him
> through, by the payment of duty on a low esti-

mate, as I contended that his picture, though
highly valued by him would not bring at auction
more than five hundred dollars.[15]

Having been favored with court patronage
in Sweden and France, Wertmüller was imme-
diately pressed into the newly organized Co-
lumbianum by Peale. Along with the Corsican
Giuseppe Ceracchi, who would soon return to
Europe to become involved in a plot to assassi-
nate Napoleon, he was certainly among those
"foreigners, who had not resided here a suffi-
cient length of time to form a correct opinion
of the character and manners of the people
of Philadelphia"[16] on whom conservatives
blamed the collapse of the Columbianum. In-
deed, Philadelphia manners forced Wertmüller
into retirement, only to resurrect him a decade
later, when Rembrandt Peale again came to
the rescue of the artist and his *Danaë*:

> Disgusted with the little taste for the Arts, as
> shown in this city, the mild and amiable artist re-
> tired with his wife to a farm which she owned
> near Chester, and devoted himself to agricultural
> pursuits; but the fame of his *Danaë* arose, and
> pursued him in his retirement, and hundreds of
> persons who neglected the opportunity of seeing
> his picture in the city, flocked to the farm-house

much to the annoyance of the painter, but to the profit of a neighboring hotel, where the company put up their carriages and dined—thus paying dearly for a sight which they disregarded when it could be had for nothing—the perverseness of fashion!

One Saturday evening, I was surprised by a visit from Mr. Wertmüller, who called to say, that since the public were now determined to see his picture, he had brought it to town, placed it in Cherry street, the house being unoccupied and he had advertised it should be open on Monday morning. I went with him to see how it was arranged and found the picture in a white-washed room with five windows, all open, placed on two carpenter's trusses, in the center, and kept erect by ropes across the room. I proposed to Mr. W., that if he would send a carpenter and some green baize, I would make a better disposition of it. I found the carpenter ready and a roll of baize at my command. The picture was placed against the wall, near an end window, half open, all the other windows closed. Baize over the wall and on the floor, and a curtain so that the picture, first seen in a large mirror (which I borrowed) in the corner opposite, could only be approached in the proper direction, and seen at a proper distance, regulated by a bar. At ten o'clock it was all ready, and the first visitor was Mr. Wertmüller himself who was astonished and delighted. Taking my hand between both of his, he expressed his earnest thanks, saying, "My dear sir, I *never* saw my picture before." It looked, indeed, beautiful, and attracted much company, which I promoted by writing some paragraphs for the papers.[17]

Other charter members of the Columbianum soon rose to the challenge presented by twenty-five cents per blushing head. "When Wertmüller's Danae made a noise in our cities," Dunlap recalled, "[Jeremiah] Paul tried his hand at a naked exhibition figure, which I was induced to look at, in Philadelphia, but looked at not long." Wertmüller's reputation had been a drawing card, but Paul's was not. His nine-by-seven-foot *Venus and Cupid*, "taken from living models," was no match for the *Danaë*. "Neither did it answer Paul's purpose," Dunlap added. "Our ladies and gentlemen only flock *together* to see pictures of naked figures when the subject is scriptural and called moral."[18] When yet another founder of the Columbianum followed Wertmüller's lead, it was too much for a "Lover of the Arts":

For a long time past there has been exhibited a painting of no great merit as a work of art, but very indecent in its composition and quite unfit for public inspection. It was however tolerated and having become profitable to its owner, other artists thinking that a shower of gold might be had for some rival Danaë, have furnished the town with Venuses and Ledas from every corner. After these abortive efforts by minor manufacturers of pictures, we have at last seen one of our most distinguished artists concentrate the whole force of his very respectable talents to produce a work of the same indecent character. Having satisfied his own imagination, the picture is offered for public exhibition.[19]

The "distinguished artist" was none other than the one who had ushered the *Danaë* through customs nineteen years before, and later had seen to her decent exposure. Rem-

2. Peter Rothermel (born Nescopeck, Pennsylvania, 1817; died Groslandmere, Pennsylvania, 1895). *The Bather*, 1865. Oil on canvas, 16¾ x 10½". Pennsylvania Academy of the Fine Arts, Philadelphia. Bequest of Henry C. Gibson, 1892. *Rothermel was active in Academy affairs, and was celebrated as a colorist. Thomas Eakins knew him well and watched him paint.*

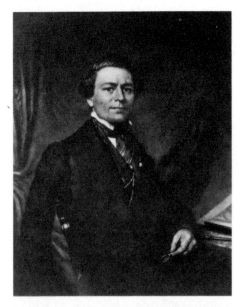

3. John Sartain (born London 1808, died Philadelphia 1897). *Self-Portrait*, about 1835. Mezzotint and stipple, 5 x 4″. Pennsylvania Academy of the Fine Arts, Philadelphia. Bequest of Dr. Paul J. Sartain, 1948. *Sartain succeeded Peale as Philadelphia's art entrepreneur, and was a close friend of Benjamin Eakins, Thomas's father, and of Peter Rothermel.*

brandt Peale naturally expected to benefit from his own venture, but he protested that his motives were not primarily pecuniary:

> After the death of Mr. W. in 1812, the *Danaë* increased his reputation, and bustling connoisseurs declared that no American painter could ever equal the beauty of its coloring. The imputation being chiefly directed against me, stirred up my pride, and I painted a picture, the size of life, to compete with it, which I thought I had a right to do, as it could not injure the deceased artist. My painting was the *Dream of Love*, founded on a slight French engraving, but varied and finished from Nature. At the sale of Wertmüller's effects I bought most of his brushes and colors, a large collection of tracings from historical engravings and bid for the *Danaë* as high as fifteen hundred dollars; but it was knocked down at fifty dollars more. I afterwards learned that the highest real bid was for William Hamilton, the artist's pseudo patron and that Mr. Dorsey, the auctioneer, seeing me so openly desirous of having it, was my competitor. A few days after he offered me the picture for $5,000. He was igno-

rant of my motive and plan. They were to exhibit my own painting and it together. Dorsey prepared to exhibit his picture to great advantage, and I hastened to display my *Dream of Love* in my own gallery. Our advertisements were together. Visitors came from his room to mine, and went from my room to his—and I was satisfied with the result; especially, as I found Mr. [Robert] Fulton, no ordinary judge, viewing my picture for more than an hour, and candidly declaring that he had seen nothing done since the days of Titian, to please him so well. Should I suppress this statement and these facts from the dread of being imputed vain?

> My picture gave me some reputation, and sufficient profit; but being sold a few years after, it was destroyed by fire from the carelessness of the exhibitor, in Broadway. Wertmüller's *Danaë* was bought by a company of five gentlemen at fifteen hundred dollars. Mr. James McMurtrie, of Philadelphia, was one of them, in whose possession I saw the picture a few years ago.[20]

The Academy Resurrected (1855–70)

In 1845 fire ravaged the Academy building and destroyed most of the Bonaparte casts. For several years there was no instruction, and between 1847 and 1855 only $1,500 was appropriated to the schools. They survived, however, and in 1855 the president was pleased to announce to the stockholders: "The number of scholars who have continued to be in attendance in the classes during the same period has usually amounted to upwards of twenty. Under the careful and judicious supervision of Mr. ROTHERMEL, who has voluntarily undertaken, on behalf of the Directors, the principal charge of this department,"[21] these toiled.

The vital force behind the resurrection of the Academy was John Sartain (fig. 3). Master of the mezzotint process when he arrived in Philadelphia from England in 1830, the year of Mrs. Trollope's visit, Sartain had the ability and character to fill the vacuum left by the late Charles Willson Peale. He was known to all of the city's best artists through his craft, and *Sartain's Magazine* soon made his name a household word. Like Peale he founded a dynasty of Philadelphia artists and art administrators, and by the Centennial year he was clearly the most influential figure in the arts in Philadelphia. Through his efforts the Academy became again an active art school.

Meanwhile, displaced by the events of 1848

26

in their native France, Christian Schussele and Joseph A. Bailly found their separate ways to Philadelphia. Schussele, born in Guebwiller in 1824, was trained in Paris (variously called a student of Yvon, Leys, Guérin, and Delaroche), where he worked as a chromolithographer. Bailly was a year younger. The son of a furniture maker, he was a skilled wood-carver himself. He contributed to the 1852 Academy Annual a "Bouquet, carved out of one piece of American Oak," which suggests that he could have found employment with one of America's French cabinetmakers,[22] and explains why he was competent to design Masonic furniture and to carve the ornamental sculpture of Philadelphia's Academy of Music. But he also worked in stone and bronze, and produced some nudes which in technical skill and treatment of anatomy are far above the American average of the period (fig. 4). Sartain started both Bailly and Schussele on the road to success in their adopted city, promoting Bailly for Masonic commissions and engraving Schussele's work, and soon both were elected to the Pennsylvania Academicians.

Among the resolutions of the Academy Board which created the Academicians, ignored but never rescinded, was one that put the responsibility for instruction and exhibition under the control of the Council of Academicians, the importance of which was not lost on John Sartain, secretary of the Council. Schussele was made president of the Council and Bailly was one of the twelve members. Then Sartain became deeply involved with rebuilding the schools:

> The affairs of the institution awakened into a state of livelier interest. . . . A number of casts were then procured from London and Paris, and a well-lighted room for study and their display was provided under the north picture gallery. Here students of art drew from the casts, and when sufficiently advanced were admitted into the life-class, a class carried on at their own expense, the Academy merely lending them the use of the room under the southeast gallery. I was always a contributing member of this life-class, and one of its committee.[23]

John Sartain had been to the London Crystal Palace exhibition of 1851 and to Paris for the 1855 Exposition Universelle, and he went again to London for the International Exhibition of 1862. But first he engraved a "righty

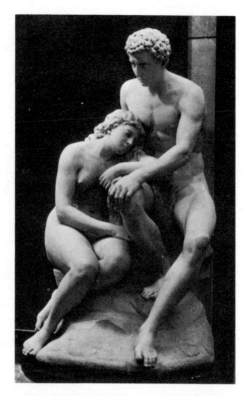

4. Joseph A. Bailly (born Paris 1825, died Philadelphia 1883). *The Expulsion (Paradise Lost)*, 1868. Marble, height 61¼". Pennsylvania Academy of the Fine Arts, Philadelphia. Bequest of Henry C. Gibson, 1892. *An émigré from the 1848 French Revolution, Bailly was a wood-carver and cabinetmaker turned sculptor. In Philadelphia, he did figures and furniture for the Masons and taught sculpture at the Pennsylvania Academy. This group, exhibited at the Academy in the plaster in 1863, is as accomplished in anatomy as anything that had then been done in America.*

dighty" Academy diploma (fig. 6), and promoted its distribution abroad, *honoris causa,* to everyone of established importance in the visual arts. He personally delivered a diploma to John Ruskin and proposed from France that Delacroix (death voided his nomination) and Rosa Bonheur be honored. Accompanied by his daughter Emily, Sartain visited the art schools of Venice, Prague, Munich, Düsseldorf, and Paris, investing the officers with diplomas. Never devoid of opinions, Sartain certainly offered his criticisms to students at the Pennsyl-

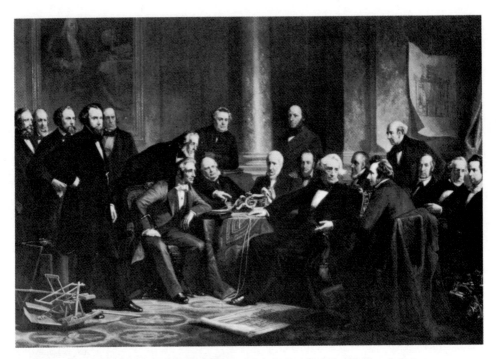

5. Christian Schussele (born Guebwiller, Alsace, 1824; died Merchantville, New Jersey, 1879).
*Men of Progress: American Inventors, 1862. Oil on canvas, 51⅛ x 76¾". National Portrait Gallery,
Smithsonian Institution, Washington, D.C. This is a small version of the painting exhibited at the
Pennsylvania Academy of the Fine Arts in 1864 and now in the Cooper Union, New York.
Schussele, also an émigré of 1848 and a friend of Sartain, taught painting at the Academy until
succeeded by Eakins, his former student, in 1878.*

vania Academy, but his role there was primarily administrative. Rothermel and Samuel Bell Waugh also contributed, but the principal teaching duties were assumed by Schussele and Bailly. Denis A. Volozan had initiated Antique and life classes, and now once again political upheavals in France provided Philadelphia students with competent French instruction.

Earl Shinn recalled his student days in the dark and ill-ventilated cellar fitted up as an amphitheater (fig. 7), where "on three evenings in each week, from the first of October to the last of April, the students who were regarded as being sufficiently advanced, drew from the living model when one was procurable. No instruction was provided, but the older students assisted their juniors to the best of their ability."[24] The search for models was described by John Sartain's son William, Shinn's fellow student in the Academy:

Models in Philadelphia were scarce. Once, for the Pennᵃ Acad. life class, Daniel R. Knight and I went out to scare one up. We found [a] strong well built man & engaged him. When he arrived at the class room & found he was asked to undress he was furious & squared off at us, and the class speadily retreated out of harm's way. He hadn't understood he was wanted nude, and took it as a serious insult.[25]

Shades of the "bashful baker" of 1795!

The means for procuring female models were described by Thomas Eakins, a fellow student of Mary Cassatt, Shinn, and William Sartain in the old Academy: "The old plan was for the students or officers to visit low houses of prostitution & bargain with the inmates. This course was degrading...& its result was models coarse,

flabby, ill formed & unfit in every way for the requirements of a school. . . . "[26] Often friends sat for each other, and a memento of one of these séances is preserved in a study of Eakins seated naked at his easel, painted by Charles Fussell, who was presumably equally naked as he wielded the brush (fig. 9).

Entering the old Academy in its last years, Edwin Austin Abbey recalled Schussele's training as being practical and sound: "The science of constructive drawing as taught by Mr. Schussele remains clearly with me, and is, in my opinion, as thorough and right as a method can be."[27] A studio comrade underscored this: "Professor Schussele . . . stood as a thoroughly trained exponent of the academic school of France. He taught the importance of truth, of going to nature for all things."[28]

Students drew from casts in the "great hall of antiques" and modeled from casts in "an adjacent gallery, which was all walled in with the Elgin friezes, and contained Thom's rather spirited group, in plain sandstone, from 'Tam O'Shanter,' " Shinn recalled. Burned into his memory was the "small windowless *oubliette,* built with a hemicycle of seats like a theatre,

[where] a dozen youths contentedly breathed vile air as they drew or wrought in clay from the strong young stevedore or olive-skinned Italian who had been engaged for a model."[29] Like Shinn, destined to become an art critic, William J. Clark, Jr., recalled this "small but enthusiastic band of students, which day after day and night after night gathered in the rather cramped and dismal quarters assigned to the modelling class in the old Academy of the Fine Arts on Chestnut Street."[30]

Christian Schussele was formally put in charge of classes in 1865, but failing health forced his return to Alsace after only a year. "For a number of years before he assumed positive responsibilities as instructor," Shinn wrote, "he was almost the only artist of Philadelphia who showed any real interest in the Academy's students. . . . The annual migration to Europe continued with an even greater energy than before, one of the main results of Mr. Scheussele's teaching being to open the eyes of the students to educational possibilities which were obviously not obtainable on this side of the Atlantic." According to Shinn the Board of Directors also encouraged students to

6. John Sartain (after a drawing by James Hamilton). *Diploma of the Pennsylvania Academicians* (detail), about 1860. Mezzotint and stipple. Pennsylvania Academy of the Fine Arts, Philadelphia. Bequest of Dr. Paul J. Sartain, 1948. *Sartain resuscitated the Pennsylvania Academicians (or P.A.'s) as an active body of artists, on whose Council he sat, along with Bailly, Rothermel, Schussele, and others. In 1862 Sartain distributed honorary diplomas to art dignitaries in England and on the Continent.*

HONORARY MEMBER

OF THE

Pennsylvania Academy OF THE Fine Arts

FOUNDED AT PHILADELPHIA A.D. 1805.

7. Charles Fussell (born Philadelphia 1840, died 1909).
*Life Class at the Pennsylvania Academy of the Fine
Arts,* December 18, 1866. Ink, 4⅞ x 5″. Hirshhorn
Museum and Sculpture Garden, Smithsonian Institu-
tion, Washington, D.C. *This sketch on a letter to
Thomas Eakins illustrates a scene familiar to Eakins
and other Philadelphians then in Paris.*

through most of the war years, when Daniel
Ridgway Knight and Howard Roberts were
vice-president and treasurer, respectively, and
Charles F. Haseltine was president. The stated
purpose of the Club, like that of its English
prototypes, and of the recently established
Brooklyn Sketch Club, was to stimulate crea-
tivity through regular meetings at which mem-
bers would propose motifs or subjects, after
which pictorial solutions would be submitted
for general criticism. Club minutes for Novem-
ber 26, 1861, show that Edward McIlhenny
failed to produce a sketch for criticism and was
"fined according to the constitution [6 cents]
for not producing one. At this juncture Mr.
McIlhenny was fined for swearing.... The
regular evening sketches were made by the
members, after which there arose a very ani-
mated discussion . . . when Messrs. McIlhenny
and Roberts were fined for swearing."[32] The

go abroad by their callous attitude to students'
needs, which drove those who could scrape up
the means to go to Europe "to obtain—it can-
not with propriety be said to complete—his
education."[31] The remembrance of Emanuel
Leutze was strong enough in Philadelphia to
draw some of the migrants to Düsseldorf, but
by now most of those going abroad gravitated
to Paris, arriving with a good provincial
French academic preparation in anatomy and
the Antique, some life-class instruction, and a
general inclination to enter the Ecole des
Beaux-Arts. In this they differed from their
Boston counterparts, who also looked to
France for guidance, but to the France of Bar-
bizon and Couture.

*The Philadelphia Sketch Club
and the Sanitary Fair (1861–66)*

At this time in Philadelphia's history a new
art association was emerging, the Philadelphia
Sketch Club, which became for a short while
one of the vital forces in American art. The
charter was signed by sixteen Academy stu-
dents or alumni only weeks before the out-
break of the Civil War. Among the signers
were: Academy curator Robert Wylie; Howard
Roberts, a student of Bailly; and Earl Shinn,
who had just been admitted to the Academy
life class. Shinn served as Club secretary

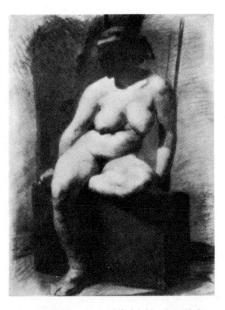

8. Thomas Eakins (born Philadelphia 1844, died
Philadelphia 1916). *Life Study (Seated Nude Woman,
Wearing a Mask),* 1865–66. Charcoal, 24½ x 18⅝″.
Philadelphia Museum of Art. Given by Mrs. Thomas
Eakins and Miss Mary A. Williams. 29-148-49. *Masking
the model for propriety was a common practice in
Philadelphia throughout the nineteenth century.*

30

subjects for sketch proposed by Howard Roberts and William Cresson on the third anniversary of the Sketch Club are fairly typical: Forgetfulness of Sorrow, the Prisoner of Chillon, Spirit of Anguish, Old Memories, Death and the Woman Playing Dice.

Members went to war on opposite sides. Daniel R. Knight went to France to study with Gleyre and Gérôme and was copying in the Louvre when John Sartain came over to hand out diplomas in 1862, but returned home in 1863 in anticipation of an invasion of Philadelphia. He arrived in time to send Robert Wylie off to France with introductions to his friends Alfred Sisley and Auguste Renoir in Paris, and to see the Great Sanitary Fair held in 1864 in Philadelphia's Logan Square for the benefit of the medical services on the battlefield.

The venerable Thomas Sully, charter P.A. and student of West, was on the Fine Arts Committee of the Sanitary Fair, along with John Sartain and Christian Schussele, which gives a good indication of the strong hand on the past in 1864. The firmness of the grip, however, is indicated by the pavilion set aside for Vanderlyn's *Ariadne* (figs. 10, 11). If no other progress in civilization and the arts had occurred since the exhibition of Wertmüller's *Danaë* a little more than a half century before, the price of admission had doubled. One customer was so horrified by the view his fifty cents afforded that he carried the vision with him for a dozen years, until it merged with nudities observed at the Centennial into an image so overpowering that he was constrained to write an article urging the managers of the new Academy to shun the methods of their new instructor, Thomas Eakins *(see p. 40)*.

Charles F. Haseltine is remembered today for his art gallery, but before he opened that he demonstrated his knack for promotion. No sooner had he joined the Sketch Club than he had members illustrating a book he was publishing. As president, almost his first act was to move to more expensive quarters, and from there to champion an exhibition probably suggested by the stodginess of the Sanitary Fair. The ploy was a $2,000 cash prize offered by the Sketch Club. The exhibition was held under Club auspices at the Pennsylvania Academy of the Fine Arts in the 1865–66 season, and William J. Clark called it the "most important

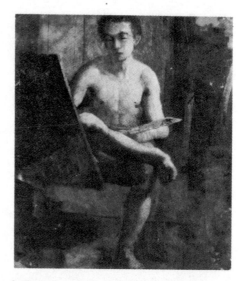

9. Charles Fussell. *Life Study (Young Art Student— Sketch of Thomas Eakins)*, about 1865–66. Oil on paper, 15 x 12¾". Philadelphia Museum of Art. Given by Seymour Adelman. 46-73-1. *One way for students to paint from life was to sit for each other, if necessary naked at the easel.*

display of purely American works that was ever made,"[33] but it was a Pyrrhic victory which almost plunged the Club into bankruptcy. Still, it managed to survive the war with few tragedies, and most of the membership returned unscathed to commiserate with Edward McIlhenny, who had bought his way out of conscription the day before Appomattox.

Such was the matrix of the early education of Howard Roberts, Thomas Eakins, William Sartain, Earl Shinn, Mary Cassatt, William J. Clark, and all the other youths who breathed the vile air in the *oubliette* under the southeast picture gallery of the old Academy building on Chestnut Street. Without some familiarity with it, one cannot understand the tremendous strides made by their generation in overcoming American prejudices.

Innocents Abroad: Philadelphia Art Students in Paris (1866–70)

In April 1866 Earl Shinn and Howard Roberts sailed together for France, stopping in Paris long enough to get the letters from Amer-

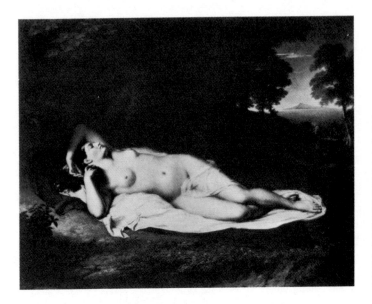

10. John Vanderlyn (born Kingston, New York, 1755; died Kingston, 1852). *Ariadne Asleep on the Island of Naxos*, 1814. Oil on canvas, 68 x 87". Pennsylvania Academy of the Fine Arts, Philadelphia. Joseph and Sarah Harrison Collection, 1878. *Notwithstanding a noble lineage traceable to Titian and Giorgione, this great American nude scandalized the public when it was learned it was based on living naked models.*

ican Minister John Bigelow[34] required for entry into the courses at the Ecole des Beaux-Arts. After applying they left Paris for Brittany, where their old Academy and Sketch Club friend Robert Wylie had established himself in Pont-Aven. He had become something of a local hero, the vanguard of an army of artists yet to come, and the focus of an active American art colony, which in the summer of 1866 included Shinn, Roberts, Frederick A. Bridgman, Benjamin Champney, and a few others.

Meanwhile, Eakins had finished four years at the Academy and weighed his future. That summer in Philadelphia he swam and watched the fireflies on the banks of the Schuylkill, and played word games in Latin, Italian, and French with the younger Sartains, Emily and William. He too inquired about the procedure for admission to the Ecole, but did not get his answer until September, when he received the following from the Perpetual Secretary of the Ecole Impériale des Beaux-Arts, Albert Lenoir, P.A.:

I am now writing to the Superintendent of Fine Arts who asked a few days ago for information on the subject of whether we have space in the studios of the school for foreigners who request admission to them, and whether they could be accorded permits. You can in consequence pick up a letter from your embassy to solicit permission from the Superintendent to study at the school, which he will accord you on presentation of your letter. Last year, all the places having been taken, we were obliged to refuse more than one foreigner which your embassy no doubt recalls. But today there is no more reason to raise obstacles. As soon as the Superintendent writes us to admit you, I will inscribe you on the list of whichever atelier you would like to choose. You will go meanwhile to see the professor of your choice, who will give you a letter for the Secretariat. Then you can begin work.[35]

Eakins (fig. 12) took the next steamship for France, and by October 12 had the necessary letter from John Bigelow. Three days later he saw Gérôme (fig. 13), who wrote a note approving him for admission to his studio. Eakins's letter from the minister included the names of Shinn, Roberts, and Bridgman, who had already applied. There were obstacles after all, and all of the Americans had been turned down;[36] Eakins now met the same obstacles, and was rejected. Bigelow despaired of the young Americans' cause. Shinn remained in Pont-Aven, but Roberts was in Paris, having come to meet a sister. He had counted on the Beaux-Arts, but now, in October, had to seek other instruction in a strange but wonderful

VANDERLYN'S ARIADNE

This most wonderful creation of the genius of Vanderlyn has been placed at the disposition of

The Fine Arts Committee of the Sanitary Fair

AS A

SPECIAL EXHIBITION,

ON THE EXPRESS CONDITION THAT

SEASON AND OTHER TICKETS,

GIVING ACCESS TO OTHER PARTS OF THE FAIR

ARE NOT TO BE ENTITLED TO ADMISSION.

ARIADNE,

(Daughter of Minos and Pasiphæ, deserted on the Island of Naxos, by Theseus.)

" An ideal of female beauty, reposing upon the luxury of its own sensation, lost in sleep, and yielding, with child-like self-abandonment, to dreams of love "

" How like a vision of pure love she seems !
 Her cheeks just flushed with innocent repose,
That folds her thoughts up in delicious dreams,
 Like dew-drops in the chalice of a rose ;
Pillowed upon her arm and raven hair,
 How archly rests that bright and peaceful brow ;
Its rounded pearl defiance bids to care.
 While kisses on the lips seem melting now ;
Prone in unconscious loveliness she lies ;
 And leaves around her delicately sway ;
Veiled is the splendor of her beaming eyes,
 But o'er the limbs bewitching graces play ;
Ere into Eden's groves the serpent crept,
 Thus Eve within her leafy arbor slept ! "

—*Tuckerman's "Artist Life."*

"In 1812 Vanderlyn painted the 'Ariadne.' This painting proved Mr. Vanderlyn's powers even more than the 'Marius,' and is, in my estimation, the finest figure of the kind I have ever seen. This picture has been purchased and engraved by A. B. Durand Esq, himself an excellent painter, and our first engraver. The engraving of Mr. Durand is worthy of it."—*Dunlap's Arts and Designs.*

Admission, - - - - - - Fifty Cents.
ENTRANCE

From the Horticultural Department, and from the Corridor connecting the latter with the Art Gallery.

11. Announcement for the special exhibition of Vanderlyn's *Ariadne*. From the *Catalogue of Paintings, Drawings, Statuary, etc., of the Art Department in the Great Central Fair*, Philadelphia, 1864.

city, and he had no knowledge of French. To his good fortune he came across a friend from Pont-Aven, Champney, who was in Paris disgruntled about his impending return to Boston. Knowing Paris and the French language, Champney took Roberts around to studios of sculptors who took on students and eventually settled on Guméry.

By October 29, however, Eakins was fully matriculated as a regular student in Gérôme's studio in the Ecole and had located a room with the painter Crépon, and that evening he acknowledged his debt to old John Sartain:

> I can never give thanks proportionate with your kindness in furnishing me with such good letters of recommendation and in entrusting me with a commission from which has sprung as my father will tell you my good fortune of entering the Imperial School. . . .
>
> Crepon sends you his regards. Much of his kindness to me has come from gratitude to you for services rendered long ago, which he begs me to assure you will never be forgotten. We look with pleasure to your contemplated visit.[37]

If John Sartain was in fact responsible for his admission it was because Eakins knew how to invoke his name, and the language in which to invoke it. Shinn gave full credit to Eakins a few years later in an article about Bridgman, and to the list of Americans who owe their entry into the regular Beaux-Arts courses to Eakins should be added William Sartain, H. Humphrey Moore, Augustus G. Heaton, and Howard Helmick—all from Philadelphia—and he paved the way for Saint-Gaudens, who was also a member of Wylie's circle.

> Frederick A. Bridgman was, I believe, among the first American students who entered the atelier of Gérôme, in the Beaux-Arts school at Paris. The little group who succeeded in obtaining admission at the date of Bridgman's entrance had been rebuffed and refused time and again. Minister Bigelow had asserted that he could solicit no more, and the news from the school was always the convenient news that it was full. At length . . . [Eakins] then a slender and not unprepossessing boy, bearded Count Nieuwerkerke in his den, having obtained access by the device of complete ignorance of French, combined with a successful deafness whenever a refusal was pronounced by a lackey; this effectual champion soon wearied the minister of the Emperor's household into signing a pass for the whole list of American aspirants.[38]

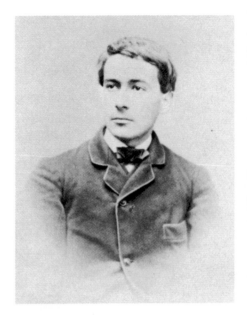

12. Photograph of Thomas Eakins, 1866. Pennsylvania Academy of the Fine Arts, Philadelphia. *Eakins sent this photograph home from Paris to Emily Sartain, his companion since childhood and lifelong friend.*

Mary Cassatt was in Paris in the autumn of 1866 seeking to further her academic training, but because her sex was admitted to the Beaux-Arts only on the model stand, the prejudice encountered temporarily by her male colleagues from the Pennsylvania Academy was permanent for her. These peregrinations were eagerly followed in Philadelphia by those remaining in the "old sanctum," that airless *oubliette* that was the life studio. Eakins learned about Mary Cassatt's problem from Emily Sartain, writing from Philadelphia, and a letter from Eakins to his family evoked a response from Fussell on December 18, 1866, in which he aired the gossip at the Academy:

> You may have a conversation on our brother artists in Paris, showing how wonderfully the French Masters were impressed by the genius and power of Young America. How [Harry] Bispham was the favored pupil of Couture or Couturier folks didnt know which. How Miss Cassatt was honored by Gerome's private lessons, how complimented Shinn felt by the notices that Gerome

13. Jean-Léon Gérôme, about 1866. Illustration from Edward Strahan [Earl Shinn], ed., *Gérôme,* New York, 1881. *This illustration from Shinn's book on Gérôme is after a photograph given him by the French artist. Shinn, a friend and fellow student of both Eakins and Roberts at the Ecole des Beaux-Arts, and before that in Philadelphia, wrote art criticism under various pseudonyms, in deference to his Quaker father.*

took of his drawing. There I have "gone and done it." Will Sartain claimed that story for himself, and I told him he should have it, but since I have started and Will most probably has already written, I will just say that Shinn wrote home that he had had a great compliment paid to him in the fact that Gerome took so much notice of his drawing, criticising its faults & C——[39]

Paris and Philadelphia were worlds apart. When Eakins studied anatomy at Jefferson Medical College, not one cadaver could be procured through legal channels. Dissection rooms at la Charité were crowded from the early hours of the morning with students of anatomy working on hundreds of cadavers, or "subjects." Crowds of models sent on by Prix de Rome laureates were available for hire individually or by family, in contrast to the situation in Philadelphia. An English artist and

essayist resident in Paris explained the morality of figure painters to his American readers, pointing out that

young officers, young attorneys, young cotton manufacturers, have, as a general rule, little right to reproach young painters with licentiousness. The artist, who was aiming at some purely artistic triumph, some masterly feat of drawing and arrangement of forms . . . thinks no more about the immoral conduct of his figures than a girl thinks of the sensual behaviour of the flowers she gathers in her garden.[40]

The morality of the Italians who posed in the "ensemble" was not taken for granted. The first families, the Stizzi, Colarossi, and Agostini, were professional in every sense, and all French artists knew the anecdote of the girl posing before students in the atelier of Ingres who suddenly hid behind a screen, screaming, "There's a man looking at me from the opposite roof!"[41]

Professors in Paris differed in how to interpret the living model. For instance, Gleyre, with whom Knight studied along with French students who would later become known as "Impressionists," criticized Monet's figure studies in terms of the Antique:

Not bad! . . . but it is too much in the character of the model—you have before you a short, thick-set man; you paint him short and thick-set. He has enormous feet; you render them as they are. All that is very ugly. I want you to remember, young man, that when one executes a figure, one should always think of the antique. Nature, my friend, is all right as an element of study, but it offers no interest. Style, you see, style is everything.[42]

But to his students, Gérôme said, "There is your model. Represent it as close as possible and before you touch your canvas know what you are going to do" (figs. 14, 15).[43] In order to know what to do, the student spent long hours of study in the dissection rooms of the hospitals and took the regular Beaux-Arts anatomy instruction from Professor Mathias Duval, bone by bone and muscle by muscle, which enabled him to know what he saw before him on the model stand. This went also for the students of Dumont, with whom both Eakins and Roberts studied sculpture. After the life model's work was done, students would pose for each other for reasons of economy, as they did in Philadelphia, and one of the subjects from

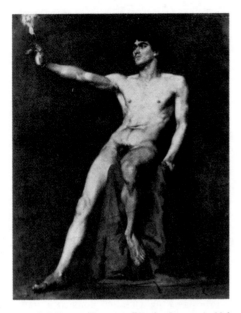

14. P. A. J. Dagnan-Bouveret (French, 1852–1929). *Male Nude Study*, 1877. Oil on canvas, 31½ x 25½". Yale University Art Gallery, New Haven. Given by Julius Alden Weir. *Dagnan, a friend of Eakins in Paris, was still in Gérôme's atelier in 1877 with J. Alden Weir, who gave this life study to Yale. It amply demonstrates the level of proficiency expected of and achieved by Gérôme's students in the life class.*

15. Jean-Léon Gérôme (French, 1824–1904). *The Artist's Model*, 1895. Oil on canvas, 19⅝ x 14½". Pioneer Museum and Haggin Galleries, Stockton, California. *When finishing, Gérôme told his students, the sculptor constantly has his hand on the model. This self-portrait, with his sculpture* Tanagra *in progress, illustrates his close study of the model.*

a portfolio dated 1867, and attributable to Eakins, is probably Roberts (fig. 16). After less than two years with Gérôme, Eakins was appalled by the run-of-the-mill Salon nude in 1868, the motif propped up with classical crutches:

> The pictures are of naked women, standing, sitting, lying down, flying, dancing, doing nothing, which they call Phrynes, Venuses, nymphs, hermaphrodites, houris, and Greek proper names. The French court has become very decent since Eugénie had figleaves put on all the statues in the Garden of the Tuileries. When a man paints a naked woman he gives her less than poor Nature did. I can conceive of few circumstances wherein I would have to paint a woman naked, but if I did I would not mutilate her for double the money. She is the most beautiful thing there is—except a naked man, but I never yet saw a study of one exhibited. It would be a godsend to see a fine man painted in a studio with bare walls, alongside of the smiling, smirking god-

desses of many complexions, amidst the delicious arsenic green trees and gentle wax flowers and purling streams a-running up and down the hills, especially up. I hate affectation.[44]

If Eakins saw the contribution of his fellow Pennsylvania Academy students Mary Cassatt and Eliza Haldeman, who had enrolled in several "Académies des Dames," at that 1868 Salon he made no mention of it, but Cassatt was exhibiting under her mother's family name of Stevenson.

Few American sculptors of the generation that was to come to maturity by the Centennial year enrolled in the Ecole des Beaux-Arts. Exceptions were Richard Greenough, Olin L. Warner, Pierce Francis Connelly, Howard Roberts, and Augustus Saint-Gaudens (Wylie had intended to do so, but turned to painting after some study with Barye). Most still preferred Italy, where teaching was only an "influence in the air," according to Shinn, who

16. Thomas Eakins (author's attribution). *Life Study
(Howard Roberts?)*, 1867. Charcoal, in two parts,
17½ x 8¾", collection of the author. *From a portfolio
dated 1867 and initialed T. E., this drawing is one of
several divided studies. Roberts entered the Ecole des
Beaux-Arts with Eakins and Shinn in 1866, and studied
with Eakins in the atelier of the sculptor Dumont.
Though plentiful in Paris, models were still an expense,
and students posed for each other. Resemblance to
known likenesses (see fig. 19) suggests that the subject
here is Roberts.*

pointed out that the teaching of French pro-
fessors was above all technical in nature:

> The young sculptor who establishes himself in
> the Eternal City or Florence imbibes delicious
> ideas of the poetry of the antique, . . . but he usu-
> ally gets little instruction of the lofty order, and
> is often seen struggling for the rest of his life. . . .
> In Paris, on the contrary, there is the intelligence
> that has resolved into a system the best art-teach-
> ing of the whole world. The student there learns
> that felicity in many sorts of technic which makes
> him able thereafter to master whatever he has it
> in him to express.[45]

.

> The American artist in Rome scarcely ever hears
> severe, healthy criticism. Unlike the American
> artist in Munich, who sees the measure of his
> success as in a mirror in the publicity of art-
> comradeship, in the enthusiastic appreciation of
> his fellow-artists, and in the discrimi-
> nating encouragement of his professor—unlike
> the American artist at Paris, for whom the harsh
> grunts of the *maître* and the merciless irony of
> the "school" quickly distinguish every fault and
> weakness—the Yankee at Rome is a little king, a
> great diner-out, a frequenter of "At Homes" and
> "Thursdays," one of the sights of the city, and a
> power that may be cultivated or neglected, but
> never weighed.[46]

Coming Home: Howard Roberts Sets Up Shop (1869–73)

Earl Shinn returned to Philadelphia in 1868
after a trip to Italy with Roberts, who re-
turned to Paris in time to see a work of his in
the Salon of 1869 before sailing. Then he too
sailed for home. Eakins followed in the fall of
1870 after six months in Spain with William
Sartain and H. H. Moore. It wasn't the best
time to come home. Shinn had come back just
in time to paint in the old Academy with Wil-
liam Sartain and Daniel R. Knight before they
departed for France to continue their studies,
and then the venerable institution closed
down. The section of the city in which it was
located was no longer stylish. Commercial in-
terests encroaching on the cultural center of
the city made it not only unstylish, but also
valuable, an irresistible combination for busi-
nessmen, of which the Academy board was now
principally composed. It was expedient to sell
the noble old building in order to help finance
the new Centennial building projected in the
developing Centre Square area, and it went to

the American Ballet Theater, with the paradoxical situation that there was more nudity in the old building as it sang its swan song, and probably more regular attendance from some of the directors than during its entire life-class history. Few exhibition facilities remained in the city. The Union League Club held occasional "Art Receptions" for ticket holders; Bailey & Co. and Caldwell's made their Chestnut Street display windows available; and two commercial galleries, Earle's and Haseltine's, were receptive to American art, with Haseltine especially favoring the work of Sketch Clubbers. But there was no official Salon.

Earl Shinn, suffering from weak eyes and color blindness, turned his full attention to art criticism, writing under his own name and the designations Edward Strahan, Sigma, E.S., L'Enfant Perdu. His knowledge of the Paris art scene, his facility with language, as well as his general adherence to the still-novel principles of Taine in the evaluation of art, make his comments on the Philadelphia group under discussion extremely valuable, even if his evaluation of colorists can be discounted. He was always poor and augmented his earnings as a penny-a-liner for the *Philadelphia Bulletin*, to which he contributed a concise résumé of the career of Roberts in the spring of 1870:

A young sculptor of refined taste, Mr. Howard Roberts, about ten months since returned from a three years' sojourn in Paris, where he devoted his time with great industry to study under the best masters. His first "patron" was Guméry, who has prepared several of the decorative groups for the new Opera House, and his second the celebrated Dumont, whose figure of Napoleon in imperial robes surmounts the Column Vendôme. In 1868 he examined the antiquities at Rome. Previous to his departure from this city Mr. Roberts's works were known for graceful sentiment and artistic delicacy. He had at that time exposed two busts representing "The May Queen," a childish beauty entitled "Shan't Have it," several portraits, including one of Lincoln, and a striking statuette of Mephistopheles. His European absence, without altering his choice of subject and cast of mind, has given him the useful habits of close work, attentive study from the living model, a constant search after positive and definite expression for each detail, a vivid feeling for character, a determination to make each touch express an idea, and other peculiarities of a high education. He had brought home with him a couple of busts, and has executed several more

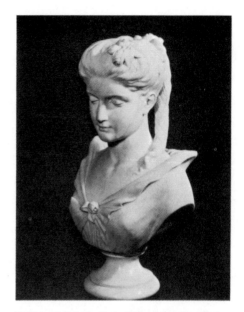

17. Howard Roberts (born Philadelphia 1843, died Paris 1900). *Eleanor*, 1870. Marble, height 25″. Pennsylvania Academy of the Fine Arts, Philadelphia. Bequest of Henry C. Gibson, 1892. *An ideal portrait made soon after the artist's return to his city from Paris.*

since his return. One of the former, executed under the criticisms of Dumont, is a lovely marble head of an Italian girl in costume,—an artistic study in every detail of flesh-treatment, hair and drapery. Another, representing...."M. le vicomte d'E——," has caught with great success the simple, straightforward gaze of youth, and shows an interesting technical success in the treatment of bushy and tufted hair. This has been cast in terracotta, an unpretending and permanent material very suitable for *genre* subjects, but not yet employed to any extent in American sculpture. The works executed by Mr. Roberts since opening his studio (on Chestnut street, near Seventeenth) are a portrait bust of a celebrated homœopathic physician, two ideal busts of females, a portrait head of a young Philadelphia lady, and a small fancy subject intended for bronze, representing a nereid in a sea-shell.... Mr. Roberts has now the ability to express a certain class of ideas—the refinements of society and cultivation—the somewhat mannered and elegant graces of Watteau and Boucher—for which there is a vacancy in American art. So long as he follows his ideal so closely, sees so clearly before him what he means to express, and confines himself

to his proper *genre,* we expect to have nothing but praise for him.[47]

The "ideal" heads Shinn mentions were put into marble and exhibited in Bailey's window in April 1870. One, *Eleanor,* was bought by Henry C. Gibson and bequeathed to the Pennsylvania Academy (fig. 17). The other, a head of a little girl with a wreath of ivy twined in her hair and falling in a strand upon her neck, was a virtuoso piece of carving, the present whereabouts of which is unknown. William Clark wrote in his column in the *Telegraph* that "like all the previous performances of this artist, it is characterized by a charming grace and refinement. This bust was cut in marble by Mr. Roberts himself, with more than usual care, and it is a very beautiful piece of workmanship."[48] Sketch Clubber Clark would not have claimed this virtuoso cutting for Roberts without knowing it to be true, which is worth remembering because it is easy to brush off the obvious craftsmanship as the work of his favorite cutter, Alfred Stauch. He knew for himself the stonecutter's craft. He was respected by artists for his industry and skill and well liked by them. He was favored by the old Philadelphia society in which he was an undisputed peer. It was a fortunate position to be in during slack times in Philadelphia, and he was able to launch immediately into commissions. Earl Shinn visited him in his studio in sweltering summer heat to see his work in progress:

> Roberts has just modeled with great success a portrait bust of a lovely child, little Miss McK——. He now has a number of orders from persons of taste and cultivation, and we suppose that pretty soon a fashionable parlor will hardly be thought complete without the images of the proprietors from his chisel, like the heads of ancestors in an old Roman atrium. Mr. Roberts will leave for Long Branch this week.[49]

Ideal heads executed during Roberts's first few years back in Philadelphia included *Lady Clara Vere de Vere,* like *Eleanor,* from Tennyson, and a *Lucile* from Owen Meredith. His most ambitious literary subject, however, and the one which would establish him as a sculptor, was a subject from Hawthorne's *Scarlet Letter: Hester Prynne and Baby Pearl at the Pillory.* Clark congratulated him on the patriotic choice of subject: "Mr. Roberts deserves credit for his brave determination to look to American literature for his inspiration, and he

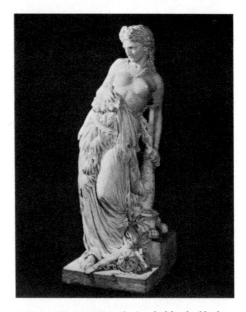

18. Howard Roberts. *Hypatia Attacked by the Monks,* 1873–77. Marble, height 66½". Pennsylvania Academy of the Fine Arts, Philadelphia. Given by Mrs. Howard Roberts, 1928. *The pagan priestess attacked by a Christian mob was an ambitious subject for the exhibition, but Rothermel's intention to show a painting at the Centennial on the same theme probably diverted Roberts to a new exhibition subject, even after he took the finished plaster with him to Paris in 1873.*

is entitled to warm praise for the shining success of his undertaking."[50]

Hester Prynne was in plaster by June 1871, and as cutting commenced had so enhanced the sculptor's reputation that before the year was out he was elected an Associate Pennsylvania Academician. Cutting was completed in April 1872, and the piece was unveiled to the public in the window of Bailey & Co. A few days later it was sold, and probably graces a Philadelphia parlor today, but its whereabouts is unknown. Another and larger literary subject Roberts embarked upon was a *Hypatia Attacked by the Monks* (fig. 18), which was already in progress when Peter Rothermel exhibited the same subject at Earle's Galleries in 1873, a work he later showed at the Centennial. Clark went out of his way in reviewing the Rothermel to point out that there was no connection between the two, but it may be that

the appearance of the Rothermel made Roberts delay the piece he probably intended for the coming Centennial Exposition:

> By a somewhat singular coincidence another Philadelphia artist had conceived the idea of illustrating the same subject, and had an important work well advanced towards completion before he heard that Mr. Rothermel was painting the picture referred to. No question of rivalry can however, come up between the two representations of a scene which Gibbon briefly but with much disgusting detail describes for the purpose of proving the corruptions of the early Church, and which Kingsley in his picturesque novel sets forth with a power of language which he has not equalled.... The *Hypatia* of Mr. Howard Roberts, the clay model of which is now sufficiently far advanced for the artist's idea to be distinctly apparent, is so different from Mr. Rothermel's work that all possibility of the sculptor having borrowed anything from the painter must be dismissed from the mind.... This statue is the largest and most elaborate Mr. Roberts has yet undertaken.... The model is not sufficiently far advanced for a criticism of its details to be proper at the present time; but it is in such a condition that the artist's purpose can be distinctly seen.... In this work Mr. Roberts has shown the same power of telling his story clearly and intelligibly that he did in his small statue of "Hester Prynne;" but independently of the poetical atmosphere that surrounds it, it reveals a power that no previous performance of the sculptor gave even a hint of; and both in the conception and execution it is certainly a work of wonderful ability and originality, its notable qualities being the more remarkable as it is the first attempt of the sculptor to model a life size figure.[51]

William J. Clark had been one of the most active members of the Philadelphia Sketch Club since 1865 so in Philadelphia matters his reviews carry weight, and he was certainly in a position to know whether there was any connection between the two Hypatias. Since 1865 he had been actively interested in the progress of the Academy, of which he was an alumnus, and in the Sketch Club, as the history of the Club records:

> It is a matter of record that he persistently, on every possible occasion advocated the idea of Club Dinners. Beginning at the first meeting under the new order, "Mr. Clark thought it would be very nice to get up a large Club supper," and he announced at the very next meeting that he "had a very good idea, viz., have the Club use all

the balance in the treasury for the purpose of a stupendous supper," and he proposed at the last meeting of the month "that all fines be put into a sinking fund to purchase a supper of large size." In February he was at it again, asking the Treasurer to "name a day when the Club could with safety enter into a contract with Augustine for something in the supper line." These and other nice hints were responsible for the first Club Dinner, November 3, 1870 ... Roberts was sublimely grand in recitation ... Clark had a very nice thing in the way of a literary-dramatic epic, but ate so continuously and uninterruptedly that he could not find time to deliver it."[52]

The first of the Club dinners was temptation enough to bring Shinn down to his old stamping ground from New York, where he now made his headquarters, and his expectations were apparently fulfilled, for the Minutes of the second Club dinner in 1870 record that "of Mr. Clark, but little can be said. He ate. Mr. Shinn produced a very solemn feeling by singing one of his comic songs. . . ." And so it went until the meeting of March 6, 1873, for which the minutes read in their entirety: "Present: Roberts, Clark, McIlhenny, Wharton and Lansdale; three bottles of wine and 100 oysters; subject for sketch dispensed with. ——— adjourned." Soon afterward Roberts returned to Paris, and the Sketch Club presented Clark a dinner "because he had no intention of going to Europe."[53] The press noted Roberts's departure:

> Mr. Howard Roberts, the distinguished young Philadelphia sculptor, has closed his studio and will sail from New York to-morrow for Europe, where he will make a long stay. He takes with him the completed plaster model of his grand statue of "Hypatia," which he will have put into marble in a studio that he intends to open in Paris. It will afford Europeans another proof of American talent in the art of sculpture. Doubtless Mr. Roberts will profit greatly by study and practice in Europe, and when he returns to America he will take the front rank among our native sculptors.[54]

"La Première Pose": Roberts in Paris (1873–74)

Roberts was in Paris for eighteen months, but kept in close touch with Philadelphia—difficult not to, considering the large colony in Paris, which now included Knight, Moore, William and Emily Sartain, Mary Cassatt, Wylie (when he ducked in from Pont-Aven), and

19. Augustus Heaton (born Philadelphia 1844, died 1930). *Caricatures of William J. Clark, Jr.,
Earl Shinn, Jr., and Howard Roberts, 1872. Philadelphia Sketch Club. Caricatures of Sketch Club
members were illustrated in the Philadelphia Sketch Club Portfolio, vol. 1, no. 1, January
1874. Shinn and Clark were the art critics most familiar with Roberts and Eakins.*

others. He also kept in touch with the Sketch
Club, sending a collection of Braun autotypes
and greetings from the "Latin Quarter Sketch
Club," in return for which he received an
edition of the short-lived *Philadelphia Sketch
Club Portfolio* (fig. 19).[55] A correspondent to
the *New York Herald* called on Knight in his
studio by the church of Saint-Germain-des-
Près:

> Knight says he is happy, don't want to come
> home, has demand for all his productions among
> the Parisian dealers, and that he will throw his
> best efforts on the canvas for the American Cen-
> tennial in '76.
> Previous to my visit Howard Roberts, the Phil-
> adelphia sculptor, had just dropped in on him.
> Roberts has also taken a studio in Paris and gone
> diligently to work. He seems to value his profes-
> sion more than his wealth, and as the latter is
> abundant we may look for great works from him
> soon.[56]

The same correspondent reported on one of
these great works in progress, a work destined
for the Philadelphia Centennial, in a commu-
niqué dated April 20, 1874:

> In a rue—to the spelling of the name of which I
> am not equal—is the atelier of Howard Roberts,
> the interior of which is a little piece of his home
> surroundings in Philadelphia transported to
> Paris—cosy, neat, comfortable, and filled with
> scraps of art of every description. In its centre
> stands a female figure in clay that would seem to
> require less than an act of the gods to bring her
> to life. It is a charming conception, full of life
> and vigor, and in execution a work that will do
> much to raise high the reputation of Philadel-
> phia for having produced a number of the best
> modern sculptors. I regret that as the work is not
> yet finished I cannot name its subject, but hope
> that your city will have an opportunity to see and
> admire its beauty. . . . It is worth noting with re-
> gard to Roberts, that the artists are almost with-

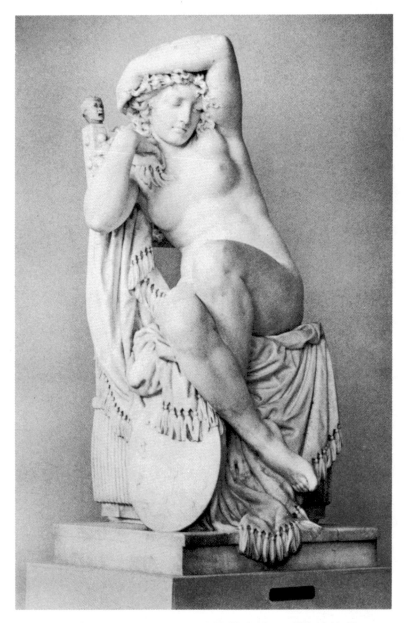

20. Howard Roberts. *La Première Pose*, 1873–76. Marble, height 52″. Philadelphia Museum of Art. Given by Mrs. Howard Roberts. 29-134-1. *To support the art motif of the nude, Roberts chose the narrative subject of the modest model posing nude for the first time.*

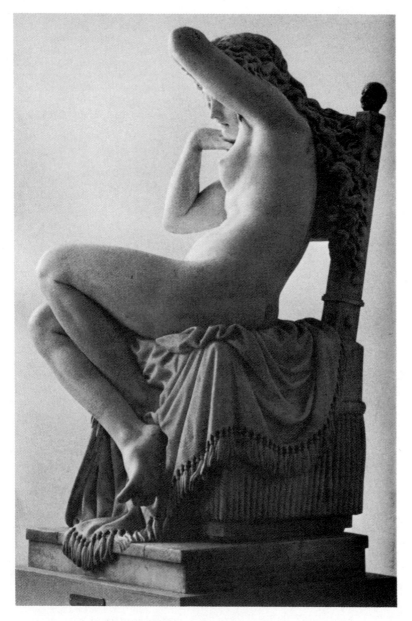

21. Howard Roberts. *La Première Pose. This was regarded by Lorado Taft as the finest American figure done up to the time he saw it in Philadelphia in 1876.*

out exception decidedly enthusiastic about him. This is a rather remarkable circumstance, as artists are much disposed to be hypercritical in discussing each other's performances. I have no hesitation in saying that Roberts is looked upon as the most promising young sculptor in Paris. His genius is unique, and he has a most happy faculty in the selection and treatment of subjects which appeal at once to the sympathies of the ordinary observer and of the connoisseur.[57]

Further notices from the Paris correspondent kept *Herald* readers informed on the progress of the female figure being modeled in Roberts's Paris studio:

Among the works of American sculptors in Paris I have to mention a full length nude female figure, by Mr. Howard Roberts, a young gentleman of Philadelphia. The subject is "The Model's First Sitting" [figs. 20, 21]. A beautiful girl is shrinkingly devoting herself to the requirements of art. She has naturally fallen into a position where every line of her figure is graceful and charming, but so modest is the expression of her face that one feels necessity alone could have overcome her reluctance to such mode of earning bread, and that a hard struggle has been made before the drapery was removed, which now hangs in delicate folds beside her. The figure is seated on a carved chair, of artistic shape, and around her lie the palette and brushes of a painter. Mr. Howard Roberts has evidently gone to nature for inspiration, though he shows careful training in classical art. The figure is well constructed, the modelling is fleshy and broad, the planes well marked, and the composition of lines and masses of shade peculiarly happy.[58]

"The French distinguish works of this character from historical subjects or traits of character, by the term '*académie*,' or an academical study," Shinn explained to American readers, "that is to say, a conscientious reproduction of some living figure, where faithful adherence to nature is more the object sought than pathos or humor or dignity. A good academic study, however, may easily include a degree of interest in the situation, and this is the case with the statue before us."[59] This exercise seemed only natural and admirable to Shinn, and no more than the renewed contact with Paris would have been necessary to start Roberts off on this new project in place of his first full-size draped figure, *Hypatia*, which he had brought along to cut. It was a challenge to do an *académie* in Paris, where models were plentiful, and the more so because it would be shown in Phil-

adelphia along with the best French work. That it would be a *succès de scandale* could have been foreseen, and even before the *Première Pose* had progressed further it was being criticized on moral grounds on the basis of the above notice in the *Herald*, which the *Springfield Republican* reprinted with the following editorial comment:

A "nude female figure" representing a mythologic goddess, naiad, or what other imagined creature you please, may be considered in its relations to abstract beauty. But this confronts the beholder with outraged maiden modesty, and to delicate minds, though the farthest removed from prudery, must bring a shock of pained surprise. There is but a step from this to the Swinburne coarsening of womanhood.[60]

"La Première Pose" and the Centennial (1875–76)

Meanwhile the national Centennial was creeping inexorably closer and Philadelphia artists at home and abroad were at work in anticipation of the exhibition. By a resolution of January 1, 1874, the Sketch Club "tendered the services of the Club to the Art Department of the proposed exhibition," a position reaffirmed exactly a year later when Roberts was named president. "The clay model holds all of the sculptor's art," Roberts later told a visitor to his studio, repeating an axiom of his trade. "This is called the life. The plaster cast is termed the death, and the completed work in marble or bronze the resurrection."[61] Roberts had left his beauty behind for this metamorphosis after eighteen months of work, and returned home. Not long after his election to the presidency, the Club issued the following broadside:

At a meeting of the Artists of Philadelphia, held at the Philadelphia Sketch Club Rooms, No. 10 Northwest Penn Square, on Saturday, March 27, 1875, was adopted the following address to the Artists of the United States:

On the 10th day of May, 1876, will be opened in the city of Philadelphia an International Exhibition of Art and Industry in celebration of the Centennial Anniversary of American Independence, which will remain open until the 10th of November following.

The management of the Exhibition is in the hands of a Commission organized under the laws of the United States, which Commission has its headquarters at No. 903 Walnut Street, Philadel-

phia. The Art Department of the Exhibition will be one of its most important and most imposing features. To this Department will be assigned a separate building of very elegant architectural design, and most admirably arranged for the effective display of all descriptions of Art works.

After the close of the Exhibition this building will remain as a Memorial Hall, and will be used as a national museum. Patriotism demands that American Artists should use their utmost efforts to make the Art Department of the Exhibition fully equal in all respects to the other departments by the contribution of works which will show the advancement of art in the United States during the past hundred years, and display to the best advantage the peculiar characteristics of American art.

As contributions to the Exhibition will undoubtedly be made by the most celebrated foreign artists, and the display of foreign works will be exceedingly rich, it is peculiarly important that American painters, sculptors, architects, engravers, and other art-workers should use every endeavor to fill the space to be assigned them with performances which will do honor to the country and to the occasion.

As the artistic success of the Exhibition will depend in a measure upon the popular enthusiasm which will be excited with regard to it, it is recommended that the artists in different parts of the country, in addition to the preparation of works of a character commensurate with the importance of the occasion, take some public action in a collective capacity for the purpose of showing the extent and character of the interest they feel.

Until the opening of the Exhibition, a committee of Philadelphia Artists will have their headquarters at the rooms of the Philadelphia Sketch Club, No. 10 Northwest Penn Square, who will be glad to communicate with their professional brethren in other cities, and to aid in advancing the interests of American art in connection with it.

P. F. ROTHERMEL, Painter.
CHRISTIAN SCHUSSELE, Painter.
F. O. C. DARLEY, Painter.
F. B. SCHELL, Painter.
P. F. WHARTON, Painter.
J. A. BAILLY, Sculptor.
HOWARD ROBERTS, Sculptor.
JOHN SARTAIN, Steel Engraver.
J. W. LAUDERBACH, Wood Engraver.
HENRY C. SIMS, Architect.
W. J. CLARK, JR., Painter.
Committee of Philadelphia Artists.[62]

Eakins had been working on a major Centennial contribution of his own. In April 1875 he wrote his old friend Shinn: "I have just got a new picture blocked in & it is far better than anything I have ever done. As I spoil things less & less in finishing I have the greatest hopes of this one."[63] In August John Sartain wrote his daughter Emily, in Paris, after a visit to Eakins's studio:

Tom Eakins is making excellent progress with his large picture of Dr. Gross, and it bids fair to be a capital work.... Since I declined the Superintendence of the Art Department of the Centennial it now must be six weeks or two months . . . [Director General] Goshorn desired to have a talk with me and I went yesterday, and I think it possible I might occupy that honored position after all.[64]

Having himself executed a portrait of Gross many years before, Sartain knew what he was talking about on the first count. As for the second, he had attended every international exhibition of importance mounted in London and Paris and was experienced in art politics and management, being then a director of the Academy, its secretary, and chairman of the exhibition and building committees, secretary of the Council of Pennsylvania Academicians, and a trustee designate of the nascent Pennsylvania Museum of Art, which would occupy Memorial Hall after the close of the Centennial. Finally, on October 1, 1875, applications for space in the exhibition were issued over his name as Chief of Bureau, Department of Art.

As the Centennial year commenced, the *Première Pose* was still in Europe, but a visit to Roberts's Chestnut Street studio by a writer for the *Sunday Press*, probably John Forney, shows that it was expected:

On viewing a photograph from the Centennial work (not yet arrived in this country), of this artist, we are inclined to . . . assert that Mr. Roberts is a genius. Even the photograph—always a poor exponent of art—suggests a very powerful and impressive piece of statuary. It is named Le Premiere Pose. . . . When the finished work arrives on this side of the sea, we shall learn the extent of the artist's appreciation on his subject, and the character and quality of his execution.[65]

To facilitate the transportation of works by American artists abroad, the United States Government ordered the Navy storeship *Supply* to sail out of New York early in January

45

22. The United States Saloon of Honor (Gallery C) of Memorial Hall as it appeared on a hot day in 1876 to an illustrator for *Frank Leslie's Illustrated Historical Register of the Centennial Exposition 1876.*

for Civitavecchia, Leghorn, and Tangier. It was to arrive at the first port of call late in January and to return to Philadelphia as early in April as possible. The steamer *Franklin* was ordered from Lisbon to Southampton, there to receive all works destined for the Centennial forwarded from Cherbourg and other continental ports. Unfortunately the *Franklin's* orders directed it to a rendezvous with the *Supply* at Gibraltar early in April for the purpose of transferring the Centennial cargo, "either of the ships to await the arrival of the other at that port."[66] The result can be imagined. American contributions so transported arrived only after the official opening of the Centennial. Because he had to have his piece in Philadelphia in time to attend to the finishing, Roberts was more fortunate. The *Bulletin* hailed its arrival in the port which only eighty years earlier had seen the arrival of our first exhibition nude, Wertmüller's *Danaë*:

All lovers of art and especially all Philadelphians who take pride in the work of Philadelphia artists, will be interested to hear of the arrival from Europe of a new work by Mr. Howard Roberts. Its "birth in the clay" was duly reported when Mr. Roberts was in Paris two years ago. He left the dead plaster in the hands of his favorite cutter, Alfred Stauch, who was to be the angel of its resurrection in marble. Mr. Stauch, after much effort to procure a proper block of marble, went to work on it at Gotha, and now the statue, needing only some finishing touches from the artist's

own hands, has been delivered safely in his beautiful studio in Chestnut street, near Eighteenth.[67]

William Clark, who had some years earlier attested to the skill of Roberts in the art of stonecutting, saw the sculptor administering the finishing touches in Philadelphia toward the end of February 1876, while the old *Hypatia* and a new *Lot's Wife* awaited resurrection:

Mr. Howard Roberts, the sculptor, has now in a promising state of forwardness two important works, very different in subject and treatment, but which are strongly marked by the best characteristics of his style, and especially by that peculiar refinement and subtile suggestiveness which have distinguished the most important of his previous performances. The larger of these two works, which is now having the finishing touches given to the marble, is a life-size figure of a beautiful young girl leaning back in a crouching attitude in a large chair. It is entitled *La Premiere Pose*, and represents a model posing for the first time in an artist's studio. It is obvious that such a subject as this must be treated with extreme delicacy and refinement of feeling, and with a sympathetic appreciation of the emotions which would animate a modest woman at such a moment, in order not to be offensive. Mr. Roberts' previous statues, such as his *Hester Prynne in the Pillory*, and his *Hypatia*—which, by the way, we hope ere long to see translated into marble—have been marked in an eminent degree not only by exquisite refinement, but by a certain dramatic power which enlists the sympathies of the beholder in the subject, and makes the fine technical qualities of the sculptures matters for admiration only as secondary considerations. This quality in Mr. Roberts' work is the more worthy of particular mention, for the reason that so many of the best modern performances, both in the way of painting and sculpture, command admiration for their technical qualities alone. The statue to which we are referring is essentially dramatic in the best sense of the word—indeed, in this respect it is the most admirable of any of the sculptor's works, unless we except the smaller figure, the modelling of which he has just finished, and to which we will refer more particularly anon [fig. 38]. It is an especial merit that the nudity of the shrinking girl is not obtruded upon the spectator except as a means of interpreting the theme and exciting the sympathies of the spectator. It is impossible not to feel a profound pity that this beautiful creature should be compelled to earn her bread by such means as this, and at the same time the whole action of the figure is so natural, so unconventional, so essen-

23. United States Saloon of Honor in Memorial Hall as it appeared on May 10, 1876. Centennial view, by the Centennial Photographic Co.

viewed, while the artist's peculiar feeling for the value of masses of dark in giving a suggestion of color to a statue—a feeling that very few sculptors possess—makes this a singularly rich work considered simply as a composition. The modelling of the figure is remarkably fine, and as a specimen of artistic workmanship it is worthy of the highest consideration.[68]

There is no space to go into the complications Sartain faced as Chief of the Art Bureau; the rivalries between Philadelphia and New York; the determination of the National Academy to make sacred cows such as Bierstadt submit to the jury; Sartain's constant circumvention of the jury by issuing invitations with the caution, "Tell it not in Gath, nor publish it by the Gates of Ascalon."[69] The Committee of Selection was composed of regional juries, but its duties were collective and not local. At various gathering places they met to cull submissions of "insufficient merit." Old-guard member Daniel Huntington is on record as regarding the French contributions to the Centennial as "intended to pamper the tastes of lascivious men."[70] So what did he think of the most French of all the exhibition nudes? In the case of the *Première Pose* it mattered little, for although no works were *hors concours,* it would have been unthinkable to oppose the work of a fellow juryman, and as president of the Philadelphia Sketch Club Roberts was *ex officio* on the jury.

"As alloter of space in *large* and in *detail I* am the hanging committee. . . . But I did not like the look of assumption it would have had, so I asked Mr. Goshorn's consent to my associating others with me in these duties,"[71] Sartain wrote Charles Perkins of the Boston Museum. Among those he associated with him was Howard Roberts. How much blame can be attached to any of the principals in the arrangements for the chaos on opening day is a moot point. Before Sartain's appointment in September, it was not realized that the space in Memorial Hall would be insufficient; only then was the Annex begun. On opening day the ships with all the sculpture from abroad had not yet unloaded in Philadelphia. Three weeks after the opening of the Centennial the following report appeared in the press:

The Art Department of the Exhibition is the one Department that will not put its house in order, and that seems to take pleasure in tormenting the

tially modest, and so expressive of the situation, that immodesty alone could take exception to it. In Powers' *Greek Slave,* and in more than one modern work of less note—although perhaps of more merit—there is an affection of modesty that is offensive to all refined taste, and in nothing is Mr. Roberts more to be commended than for his treatment of such a very difficult theme as this, in such a manner that its spiritual rather than its purely physical phases should especially invite attention. The action of this figure, with the feet drawn up under the chair and the body twisted and the arm thrown up to shield the face [fig. 24], is a peculiarly complex and difficult one. It is one of those instantaneous actions so difficult to interpret, and if interpreted unskilfully so thoroughly disgraceful, that it was a bold thought in the sculptor to attempt it. Mr. Roberts has been no less successful in this and other technical matters than he has in the treatment of his subject. Notwithstanding the peculiar complexity of the action, the figure falls into graceful and harmonious lines from whatever position it is

visitors with half-promises, statues in boxes seen through slats like animals in a menagerie, and pictures piled up six deep against the wall waiting in vain for a hanger.[72]

Probably because they were already in Philadelphia, the sculptures placed in the main American "Saloon of Honor," Gallery C in Memorial Hall, were all by Philadelphians: Pierce Francis Connelly, Joseph A. Bailly, and Howard Roberts (figs. 22, 23). William J. Clark saw the *Première Pose* again there in its final state:

> In the United States Department there was no piece of sculpture which was marked by such high technical qualities as the *Première Pose* of Howard Roberts—a work which was almost as much a product of the schools of Paris as the admirable performances exhibited in the French Department.
>
> It would not be doing justice to this beautiful statue to intimate that its merits are exclusively of a technical character.... The subject is a young woman preparing to pose undraped, for the first time, in a painter's studio, and the sculptor has indicated his own appreciation of the fact that the situation has both a comic and a tragic side, by the grotesque comic and tragic masks which he has added as decorations to the uprights of the back of the chair [figs. 25, 27].... This figure, however, is such an absolute triumph over a great number of technical difficulties that it is particularly well worthy of consideration for its technical qualities alone. Its striking and peculiar merits could only have been achieved by a man who understood the human figure thoroughly, and who had gained his knowledge of it, not from the works of other men, but from a close and laborious study of nature. They assuredly could not have been achieved by one who depended chiefly upon some real or fancied inner light rather than upon absolute knowledge. From whatever point of view this statue is observed, it is graceful, and to secure a harmony of lines along with such a complex attitude, was in itself an achievement of the first artistic importance. But, the lifting of an arm over the head so as to partly shield the face, the bending of the other arm for the purpose of grasping at the loose drapery with which the chair is covered, the peculiar twist of the body, and the pressure of the legs against the lower part of the chair, all give emphasis to the muscular and other markings of the figure in such a way that the artist, in working out his problem, must have found the gulf between absolute success and total failure a very wide one. As will be seen by a reference to

the engraving, the artist has marked with much emphasis as well as much delicacy the great variety of muscular movements with which he has to deal. The engraving, indeed, can give but a faint idea of the beauty of some portions of the work, as, for instance, the delicate markings of the flexions of the knees, or of the junction of the right arm with the shoulder. The workmanship, however, is so fine throughout that it would be an almost endless task to attempt a detailed analysis of it....[73]

With the knowledge of a professional sculptor and the gift of hindsight Lorado Taft, who as a youth visited the Centennial art galleries, was later able to put Roberts's Centennial entry into the larger context of American sculpture:

> The change in American sculpture which the Centennial period ushered in was not one of name alone, but of spirit—the working of new influences now became evident. These influences were completing the exchange of a cold, impersonal classicism for an expressive and often picturesque truth, destined to attain in its highest manifestations to a new idealism. Broadly speaking, it was the substitution of the art of Saint Gaudens for that of Hiram Powers.... Though Powers died but three years before the Centennial Exposition in Philadelphia, his work was already largely discredited; that is to say, it had long since ceased to be the standard for younger men.... Further, while tastes were changing at home, an artistic revolution had taken place in Italy where the native sculptors had declined to "do Greek" any longer, betaking themselves to those romantic, picturesque, and *genre* subjects and methods which have held sway ever since.... In 1876 Mr. Story was our most noted sculptor abroad, and Palmer the most popular at home.
>
> Meantime others beside Richard Greenough had discovered Paris. At least three young American sculptors had enrolled in the Ecole des Beaux-Arts before the Franco-Prussian War. One of this number, Howard Roberts of Philadelphia, made his début [*sic*] at the Centennial Exposition, with a figure, "La Première Pose," which was so superior in technical qualities to the mass of American work that it created a sensation. The idea, however, foreign to American experience and tastes, lent itself to a worthy sculptural rendering.... It is conceived as sculpture, and it is constructed. There is certainty in the drawing and firmness as well as delicacy in the modelling, and finally the marble has been carved with intelligence and precision. To some tastes the precision is indeed overdone, there being a sug-

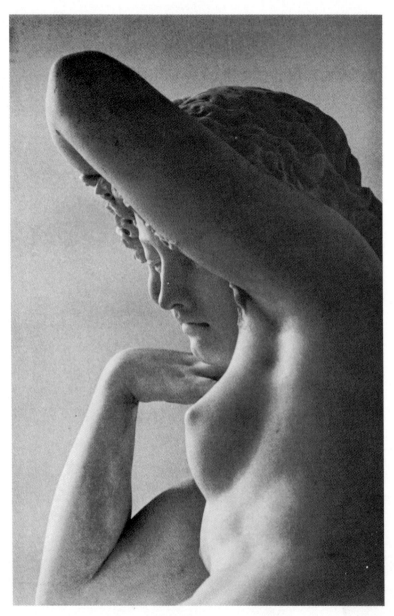

24. Howard Roberts. *La Première Pose* (detail) .

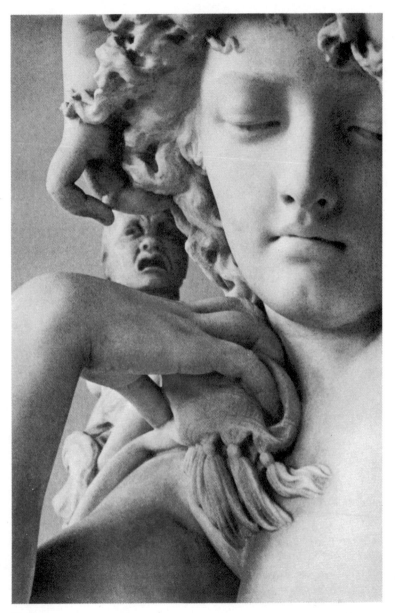

25.

25–29. Howard Roberts.
La Première Pose (details).

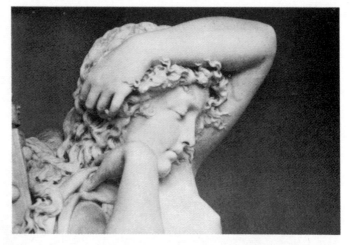

26.

27.

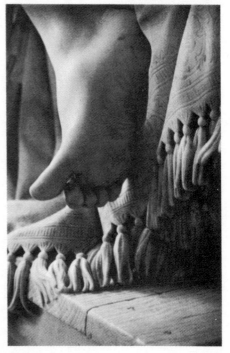

28.

29.

30. United States Army
Post Hospital Exhibit,
official photograph of
Centennial Exhibition
1876. *A victim of the N*
York establishment, th
great Gross Clinic *by*
Eakins was rejected by
Committee on Selectio
the Art Department. L
by Dr. Gross to the Arn
hospital exhibit, it was
hung among micropho
of the body scales of fle
mock-up papier-mâché
patients, and rubber
spittoons.

gestion of modern Italian handicraft in the
elaborate fringe of chair and mantle and the
conspicuous palette, with its running colors; but
after all it is the well-modelled figure which pre-
dominates and which satisfies us through a grace
extending literally to the finger-tips. Hands had
not been so well done before in the history of
American sculpture. Compared with the knowl-
edge and control of the body shown in this work,
many of the earlier statues look almost like exam-
ples of poor taxidermy; the features, the parts,
and the superficial markings are all present, to
be sure, but there is no feeling of bone and mus-
cle underneath. With the French schooling came
not only a new impulse in the spirit of American
sculpture, but the demand for a comprehensive
knowledge of the physical structure. Henceforth
the sculptor must know his theme.[74]

Howard Roberts was awarded a medal for
his *Première Pose*. H. H. Moore and Emily
Sartain were also medaled, and Bridgman got
good reviews. Eakins was well represented with
six works, and his *Chess Players* won warm
praise, but the work he had painted for the
Exposition did not appear in the art galleries.
As a part of the United States Government ex-
hibit at the fair a prefabricated Army Post
Hospital was erected and furnished with

papier-mâché patients and photographic
thology exhibits, and while it might not h
attracted art lovers in droves, the exhibit
well attended. Located between the Uni
States Government's main building and one
the busiest scenic railroad platforms, it was
no means off the beaten path. Also, a Cent
nial medical convention in the city, chaired
Samuel David Gross, was attended by th
sands of American and foreign medical a
military men, many of whom must have se
the *Gross Clinic* there in the Post hospi
where it was exhibited, on loan from Dr. G
himself (fig. 30) .

The *Gross Clinic* reflects Eakins's passion
anatomical research. The subject is a result
his clinical studies begun at Jefferson and
Pennsylvania hospitals in 1862, intensified
Paris with Duval, and continued with Pro
sor Gross in 1874 and 1875. Thus it bears so
relation to Roberts's anatomical *académie*, a
so its mention is not out of place in this ess
Another painting by Eakins, however, is
exact parallel, and cannot be overlooked
this context: *William Rush Carving His A
gorical Figure of the Schuylkill River* (fig.
Already in the study stages when Eakins be

blocking in the *Gross Clinic* in April 1875, it is coeval with the *Gross Clinic* and the *Chess Players* in conception and construction, despite its later date of completion. The circumstances surrounding the making of this painting are worth examining in some detail, and for this it is necessary to take a look back.

The New Academy and Eakins: Nudes and Prudes in Philadelphia (1868–78)

Not long after Eakins went to Paris to study, Christian Schussele returned to Alsace in delicate health. John Sartain had been hatching in his mind a new Academy, and when he went to Paris for the Exposition Universelle of 1867 it was with the determination to talk Schussele into coming back to direct the studio program. In Paris he stayed in an inexpensive hotel frequented by Wylie during his annual pilgrimages from Pont-Aven and known to Eakins, Roberts, and Shinn. His own movements were quixotic, but he did see the students in Paris and probably visited the Ecole des Beaux-Arts with them, for it had been revamped since his previous visit.

Back in Philadelphia a competition was held for a new Academy building. The designs first submitted, according to Sartain, were attractive but unfunctional, so he drew up new specifications himself:

My long practical experience in the working of the institution having made me better acquainted than any one else with its needs, I was then asked to prepare plans for the distribution of the classrooms and galleries on both floors . . . which were the province of the architects selected, Messrs. Furness and Hewitt. Thus commissioned I entered on the task with all my heart, and was enthusiastic to the degree that I felt as if the design and my individuality were merged into one. I could have breathed the prayer of Socrates: "O my beloved Pan, and all other gods, grant me to be beautiful within!"[75]

Schussele had come back to preside over the suspension of life classes in the city. For a few years he taught in the old building before the Academy casts were removed to a soldiers' home on Filbert Street, and then to a studio on South Penn Square, where he conducted classes emphasizing the Antique. Bailly left the city for Caracas, where he had an important commission. Just then Howard Roberts and Thomas Eakins returned home fresh from

the hospitals and life studios of Paris, in time to assist Sartain (and all the gods) realize his dream, as Shinn recalled, even if Sartain passed it over in his memoirs:

The best counsels were invited as the work progressed. For the draining of the floor of the modelling-room, and its arrangements for hoarding masses of moist clay, and abundant water facilities, advice was asked of Mr. Roberts the sculptor; similarly, for the largest life-class room, the lighting was not projected until after taking advice from the professor of the Sketch-Club life-class, Mr. Eakins. The arrangements are, therefore, practicable as well as enormous in scale. A good thought was the providing of a private door for the admission of the life-models near the porter's office, so that these personages are not seen by those inside the building until they emerge in what may be called a plastic condition from the dressing-room.[76]

Meanwhile, there was no school of the nude in Philadelphia. Between Sketch Club dinners William Clark promoted with vigor the establishment of a life class. At a meeting of the Club on February 5, 1874, his proposal that such a class be held on the premises (then 523 Walnut Street) on an evening other than Club night met with such enthusiasm that he was acclaimed manager of the class. "Mr. Scheussele would have been invited to take the direction of this class, had it not been known that he was in extremely infirm health," the old wartime secretary of the Club, Earl Shinn, wrote later. "The invitation was accordingly extended to Mr. Thomas Eakins, a pupil of Gérôme, and was accepted with cordiality."[77]

Eakins's return home had contrasted markedly with that of Roberts. He had not in his student days submitted to the Salons, and indeed attempted to make his first picture only after completing eight years of study. That was in 1870 in Seville. A year later his debut in Philadelphia was at a Union League Art Reception where he exhibited *The Champion: Single Sculls*, today better known as *Max Schmitt in a Single Scull* (now in the Metropolitan Museum of Art, New York). The *Bulletin* critic, probably Shinn, commented then that "the artist, in dealing so boldly and broadly with the commonplace in nature, is working upon well-supported theories, and . . . gives promise of a conspicuous future." The *Inquirer* said the whole effect was "scarcely

satisfactory."[78] Like Roberts, Eakins planned an exhibition piece from American literature, Hiawatha, but abandoned it: "It got so poetic at last [that] when Maggy would see it she would make as if it turned her stomach. I got so sick of it myself soon that I gave it up. I guess maybe my hair was getting too long for on having it cropped again I could not have been induced to finish it."[79]

His portrayals of members of his family in their daily walk were not of a nature to attract commissions. His most complex pictures of the period are the rowing, sailing, and poling pictures, which I see as extensions of the experiments in locomotion that Marey initiated in 1867 in Paris with the help of anatomy professor Duval when Eakins was his student. The analysis of the "commonplace in nature" through "well supported theories" led the National Academy of Design to reject his *Schreiber Brothers* when submitted to their Annual, and thereafter Paris and London saw more of his work than did either New York or Philadelphia until the Centennial. His fame as a figure painter had, however, been noticed by the artists, and on April 2, 1874, Eakins wrote Shinn, then in New York:

If your friends of the Sketch Club really want my corrections of their drawings they can have them for the asking; that is if the majority of the club desire them. I cannot of course act on the suggestion of one of them to my friend. I don't know them as you say. I only fear some of them are of a kind who would believe themselves more capable of teaching me than I them, but of this, you know best and I will make no account. It is always a pleasure to teach what you know to those who want to learn.[80]

"Mr. Eakins at once demonstrated not only that he was thorough master of his subject, but that he had a distinct genius for teaching," Shinn recalled. "His pupils developed that enthusiastic regard for him which zealous learners always feel for a master whose superior attainments they unqualifiedly respect."[81] Eakins enjoyed it as much as his students. After a year he wrote to Shinn, "My life school boys seem to be getting on very well considering the little time they have. Some are very earnest. But some continue to make the very worst drawing that ever was seen."[82] By the beginning of the Centennial year classes had moved to new quarters at 10 Northwest Penn Square

and were held every Wednesday and Saturday evening. They were open to members and non-members alike, to old friends like William Sartain and Charles Fussell and to professionals like Alexander Milne Calder, as well as to tyros like Thomas Anshutz, Charles Stephens, and James B. Kelly, all three of whom would later become Eakins's assistants at the Academy.

Clark gave the class he managed good press coverage:

The rooms are crowded every class evening with students, who are not only working with diligence and enthusiasm, but who are making great progress under the instruction of Mr. Thomas Eakins. If the rooms were four times as capacious as they are, they would scarcely accommodate the students who are anxious to avail themselves of the facilities which the class affords. This class will remain in operation until the schools of the Academy of the Fine Arts open—which they are not likely to do this season—and it is not improbable that it will continue after they do open, as it offers advantages that the Academy will not offer unless its management is much more intelligent and appreciative of the true end and aim of art study than it has been in the past.[83]

Twenty-two artists and art students had signed and submitted a petition composed by Clark only a month earlier, for "the use of the life class room in the new Academy of the Fine Arts building, from the first of February next, for the purpose of conducting an evening life class. Mr. Thomas Eakins, who has for a long time past been acting as instructor of the class conducted by the Sketch Club has volunteered to act as instructor."[84] Eakins had just put the finishing touches on the *Gross Clinic*, which was still in his Mount Vernon Street studio under wraps.

John Sartain was a party to these arrangements. He proposed to the Board of Directors of the Academy that Schussele and Bailly be reappointed to teaching posts with "evening lessons to be given by a competent assistant," whose appointment could wait until the fall of 1876.[85] Following the close of the Centennial Exposition, the Committee on Instruction confirmed the appointments, with Schussele, as professor of "Drawing and Painting the Human Figure, Composition, & c," to draw a salary of $1,200, and, in the evening, without compensation, his place "supplied by a competent substitute in Mr. Thomas Eakins."[86]

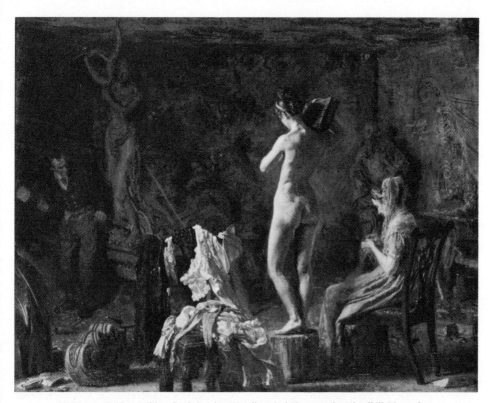

31. Thomas Eakins. *William Rush Carving His Allegorical Figure of the Schuylkill River*, 1877. Oil on canvas, 20⅛ x 26½". Philadelphia Museum of Art. Given by Mrs. Thomas Eakins and Miss Mary A. Williams. 29-184-27. *This work was the result of painstaking research and study beginning in 1875, if not before. Eakins interviewed people who had known Rush, saw Rush's studio, and studied the works of the artist. He then did his celebrated painting of a nude figure, using his historical research for the accessories necessary to support the motif.*

Shinn joined the effort to make Philadelphia's Academy as thorough a training ground as the Paris Beaux-Arts, and presented without remuneration a series of public lectures modeled after those he and Eakins and Roberts had heard Taine deliver when they were students together in Paris.

It is unlikely that the conservative faction of the Academy Board of Directors even took notice of the unpaid assistant who came in the evenings with his own group of students from the Sketch Club until Eakins proposed that the Academy advertise for models in the *Public Ledger*, at $1.00 per hour, conceding the privilege of wearing a mask and being accompanied by their mothers. The Committee on Instruc-

tion deliberated: "The question of masking the female model and requiring her to be covered during her periods of rest was discussed. Decided that it should be optional with the model—with a preference for entirely dispensing with the mask and other covering."[87] The model could then be observed moving around between poses in her "plastic condition," as favored by Eakins. The students, however, were not the only ones to observe the movements of the model:

It was the habit of rare old Edward Shippen, of patrician stock extending back into the roots of the town, to take a walk after dinner; and as the Academy was a novelty, he one night shaped his course up there. On Cherry Street, at the rear of

32. Thomas Eakins. *Studies for "William Rush Carving His Allegorical Figure of the Schuylkill River,"* 1875–76. Pencil, each 7¼ x 4⅝". Hirshhorn Museum and Sculpture Garden, Smithsonian Institution, Washington, D.C. *By April 1875 studies of Rush sculpture were under way. Here the positions of* Washington *and* Nymph with Bittern *are established, but the* Schuylkill Freed *is still tentative.*

the building, there was a door with a lamp over it which admitted to the Schools. The door was open, why not step in? He entered the hall; nobody was there. He edged on to a door at the left where a light shone from inside, and he ascended a step or two and found himself in a large circular classroom, silent, but full of students at work. He tiptoed around behind them, looking over their shoulders at their charcoal drawings. It never occurred to him in his innocence of the elements of art that they were all drawing the same thing. But round he went on the circular platform until a movement of the nude girl who was posing under the light in the center of the studio attracted his eye.

"My God!" he cried. "She's alive!" and he rushed from the room, and out Cherry Street to seek the protective regions of antiseptic society.[88]

The conservative reaction to Eakins, and to his "opinion, then and before avowed, that the study of the living model should not be based on the Antique,"[89] was in all likelihood prompted by an article in the *Penn Monthly* entitled "Art?":

In what other decade of American history than the last would we more naturally look for the Opera "Buff," the Blonde Troupes, Anatomical Museums, Variety performances like the "Naked Truth," the nudities of the Centennial Art Gallery, and the public exhibition of Vanderlyn's "Ariadne," and Cabanel's "Birth of Venus?"

It will be said that art, like innocence, knows no sex; that practice in every department is necessary to the thorough artist, and that what must be painted in the life-school, may surely be shown to the public. To which we reply that art, a personification, does not so much concern us in this regard, as its followers, who are persons; and as to the rest, all depends upon what we mean by "the thorough artist." To paint well the human figure, models are necessary; but on the grounds already stated, and with the limitations to be made, we deny that to paint the human figure utterly naked *is* to paint it well. And to paint it in any condition of exposure that lowers our sense of the dignity of the human being, should be forbidden by directors of life-schools. We admit this requires the exercise of discretion, but it is to exercise discretion that they hold their positions. . . . Because public opinion elsewhere tolerates the hiring of female models, shall we debase our standard to the same level? Because a painter—we cannot say artist—chooses to sit for hours to depict a naked woman of purchased presence, and—to make the occupation both prof-

33. Thomas Eakins. *Studies for "William Rush Carving His Allegorical Figure of the Schuylkill River,"* 1876. Pencil, each 7¼ x 4⅝". Hirshhorn Museum and Sculpture Garden, Smithsonian Institution, Washington, D.C. *Eakins made exhaustive costume studies. John Lewis Krimmel's* Fourth of July in Centre Square *was the source for the clothing of Rush, and other contemporary paintings provided the dress of the chaperone and the model's garments carefully hung over the Philadelphia Chippendale chair. The studies after Krimmel were made in the galleries of the new Pennsylvania Academy after its opening in the spring of 1876.*

itable and respectable—sends to a public gallery his shameless copy, have men who are gentlemen and delicate-minded ladies whom the law defends from some other public indecencies, no protection? Has a Hanging Committee no right of refusal if the *technique* be correct?[90]

A few months after the appearance of this article in May 1877, the Board roused itself from its customary lethargy and directed Christian Schussele not to delegate his authority in any of his classes, beginning a year of official exile for Eakins from the life classes of the Academy. John Sartain was about to go to Europe as United States Commissioner for another international exposition, and he was in no mood to take part in a dispute he could not take too seriously. Schussele, when required to make a statement on the debate, said:

Drawing from the Antique, which I insist upon as absolutely necessary for beginners, has many advantages, among others, its immobility never changing place nor light; the uniform color showing the form more clearly and truly than in life, where the various tints of the flesh often bewilder the young and inexperienced student.[91]

It was clearly within the province of the Board to deny him official function, and Eakins would not oppose Schussele, so he moved back with his "boys" to the Sketch Club quarters. By charter the Academy could not deny the premises to a practicing artist, however, and Dr. W. W. Keen was empowered to appoint a Chief Demonstrator of Anatomy. He appointed Eakins. During the year that he was barred from the life class Eakins made the Artistic Anatomy course the most thorough in the world, so the results of the debate were the reverse of that intended by the conservative opposition. William Sartain carried the dispute to France for adjudication, addressing the question of whether figure study should be based upon the Antique or Nature to his and Eakins's old professor, Léon Bonnat, who gave a predictable response:

The living model! . . . it is Nature, it is life, it is the beautiful, the true! It was only by studying and understanding Nature—the living model—that the Greeks arrived at perfection. If they had confined themselves to copying and imitating their predecessors, they would have produced

Egyptian or Indian art; and, *as every one who imitates is always inferior to his model,* they would have produced bad Egyptian or Indian art, in place of those marvelous sculptures which we all admire.

If they arrived at this result, it was only by a profound study of Nature, of man.

Let the student abandon himself to the study of Nature, of the living model. Let him analyze, and measure, and penetrate into its secrets. Let him study anatomy, and understand the causes that swell or diminish the muscles. Let him know that there is beauty only where there is truth. All the grand schools of art—the Greek, the Florentine, the Spanish, the Dutch—all were inspired directly from Nature. Outside of Nature there is no safety.[92]

All of this was going on while Eakins was working on the *Rush* painting, and the Philadelphia controversy must have stimulated him. Roberts and Eakins had both been subjected to the limitations imposed by lay prejudice in their Academy student days, and both had made exhaustive study of the nude in France. Gérôme told his students that when finishing a work the sculptor's hand is almost constantly on the model, and Philadelphia had not come so far in civilization and the arts since the days of Robert Edge Pine to tolerate that on Chestnut Street, even if Roberts could have found a model willing to pose. He could have had Stauch's help in cutting the *Hypatia* in Philadelphia (the German was a resident cutter for Struthers & Co.), so he might have had his nude subject in mind before departing for his second Paris sojourn in 1873. Like Eakins he could not simply do a nude and call it art, and with the possible exception of a "fancy subject" done in 1870 Roberts had not made a nude sculpture, even though he spent years in Paris building up life studies in clay and tearing them down. In 1868 Eakins had said, "I can conceive of few circumstances wherein I would have to paint a woman naked, but if I did I would not mutilate her for double the money."[93]

Eakins and Roberts both conceived the same circumstance to support their first academic exhibition nudes: a model posing for the first time in the nude for an artist, an appropriate subject in support of the motif, and one which was close to the experience of both artists. The sculptor chose the moment an inexperienced model first disrobed before a

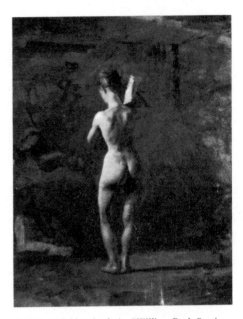

34. Thomas Eakins. *Study for "William Rush Carving His Allegorical Figure of the Schuylkill River,"* 1875. Oil on canvas, 14¼ x 11¼". The Art Institute of Chicago. Bequest of Dr. John J. Ireland. *Each of the several known life studies for the model in the painting is faithfully done after a specific model; none is generalized. The model holds* Webster's Dictionary *for proper weight distribution.*

painter, while the painter celebrated the same moment in the sculpture studio. Eakins was not then a member of the Sketch Club, but he knew many of the members, and even before Roberts came back from France Eakins was teaching Clark's Sketch Club life class. There is no more reason to think that news of Roberts's work-in-progress inspired Eakins to his interpretation of the subject than that Rothermel's *Hypatia* had influenced Roberts, but the flow of news was free and constant, and Earl Shinn had been to Paris and back while the *Pose* was in the making.

Eakins was already researching period accessories for the finished painting by April 1875,[94] as he was blocking in the *Gross Clinic* and wrapping up a year of life-class instruction. Some of the beautiful nude studies for the figure of the *Nymph with Bittern*, such as that in the Art Institute of Chicago (fig. 34), must

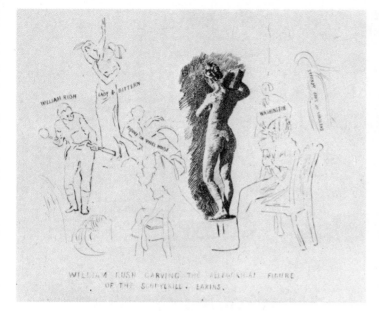

WILLIAM RUSH LADY & BITTERN

WILLIAM RUSH CARVING THE ALLEGORICAL FIGURE
OF THE SCHUYLKILL. EAKINS.

35. Thomas Eakins. *Line Reduction of "William Rush Carving His Allegorical Figure of the Schuylkill River,"* 1881. Pen and ink, 9¾ x 12". Hirshhorn Museum and Sculpture Garden, Smithsonian Institution, Washington, D.C. *Illustrating the painting for the catalogue of the Pennsylvania Academy's 1881 special exhibition of paintings by American artists at home and in Europe, this sketch shows that study from life is the subject and the motif, and that Rush and his sculptures are supporting characters.*

date from this time. As the painting evolved, it became Eakins's most eloquent statement on the controversial question then smoldering in the breasts of the Academy directors: study from the nude. Aside from being a masterful piece of painting, it is an allegory in its own right, a "Triumph of American Art," using as its historical justification an incident that had become legendary in Philadelphia, even though it was not really that far removed from living memory. Rush had been alive and well in Philadelphia when John Sartain arrived from London, and in Eakins's student days his *Nymph* was still in Centre Square. When Eakins returned home from his years of study in Paris, the sculpture had been moved to the forebay of the Fairmount Waterworks, and the model who posed for the *Nymph* was an old lady. The principal subject of the painting is the model, everything else being employed to lend verisimilitude, in the manner of Gérôme's historical works on which it is based, which Eakins's own line reduction of the picture for an Academy catalogue proves (fig. 35).

Eakins's system of perspective is, fundamentally, Albertian one-point perspective. The point of sight is the point corresponding with the position of the eye of the artist standing directly in front of the subject, supposing the scene to be real. In addition, the laws of focus of the eye are recognized and accounted for. In order, therefore, to see the picture properly, any observer should stand at the proper distance opposite the "center line" and look directly at the "point of sight." Eakins expected his paintings to be hung in such a way as to permit this. In looking at this painting, therefore, one must look directly at the nude, who is on the center line, with the eyes fixed on the nape of the neck, from a distance of about three feet. The result is a startling illusion of solid forms existing in finite indoor space. This differentiates Eakins's result from similar works by Gérôme (figs. 36, 37), whose enamel finish invites the kind of minute inspection customarily given only to Church and Bierstadt in America. Eakins's recognition of focal plane and center of attention makes his optical studies as advanced as the very different optics occupying the Impressionists at the same moment.

36. Jean-Léon Gérôme.
King Candaules, painted
1859. Photogravure from
Edward Strahan [Earl
Shinn], ed., *Gérôme*, New
York, 1881. *Eakins based
his* Rush *composition on
a picture such as this by
Gérôme, who chose to
support his figural motifs
with subjects from
mythology, history, and
the exotic Orient; Eakins
took his subject from an
incident in local
Philadelphia history.*

The New Movement: A Philadelphia Nude in New York (1878)

In 1878 Eakins had the opportunity to exhibit his own *académie* in a landmark exhibition, the first Annual Exhibition of the newly formed Society of American Artists, held in the Kurtz Gallery in New York. In writing on Roberts's *Première Pose* at the Centennial, Taft said, "Henceforth the sculptor must know his theme." After 1878 and the exhibition of Eakins's *William Rush Carving His Allegorical Figure of the Schuylkill River,* the same could be said for figure painting in America. So much water had passed under the bridge that it is easy to forget that it was only eighty-four years since Wertmüller arrived in Philadelphia and the bashful baker fled the model stand in Philadelphia's first school of the nude in Independence Hall. Asher B. Durand was still alive, venerated as the father of American landscape, and Church and Bierstadt were active. The National Academy had grown old and moribund under Worthington Whittredge, Thomas Hicks, and Daniel Huntington, whose own retrenchment in 1877 was responsible for the foundation of the Society of American Artists by young sculptors and painters professionally trained in Munich and Paris, and coming to be known under the banner of the "New Movement." Eakins was among

them. When their first show opened in New York it was the Munich group, led by William Merritt Chase, that excited the greatest interest, so it is not surprising that the most informed view of Eakins's contribution came from the two people closest to his work, William J. Clark and Earl Shinn. In *The Nation* Shinn gave this appraisal:

> The apparatus of hiring properties, arranging incidents, and employing models, by which conscientious works of art are elaborated, seemed to have been used only with two works produced in this country—Mr. Eakins's "Rush Carving the Fountain" and Roberts's "Lot's Wife," a statue [fig. 38]. Both of these, though not above discussion in regard to the selection of subject, were thoroughly studied and artistically satisfactory. The painter of the fountain seemed to have a lesson to deliver—the moral, namely, that good sculpture, even decorative sculpture, can only be produced by the most uncompromising, unconventional study and analysis from life, and to be pleased that he could prove his meaning by an American instance of the rococo age of 1820. Mr. Roberts's statue was a nightmare theme treated with perfect self-command, originality, and knowledge. Works of this sort of thoroughness—and of higher interest and beauty if possible—are what will be needed to make an exhibition "go" next year.[95]

Clark, in his column in the *Evening Telegraph,* defended Eakins:

37. Jean-Léon Gérôme. *The Snake Charmer,* about 1870. Oil on canvas, 33 x 48 1/16". Sterling and Francine Clark Art Institute, Williamstown, Massachusetts. *Gérôme demonstrates here his command of the human figure—his "possession" of the subject. What differentiates this from the Rush by his student Eakins is the high finish and attention to minute detail in the one, and the fidelity to optical principles of focus in the other.*

Most of the gentlemen who discuss art matters in the New York newspapers have a way of either ignoring the existence of the works of Philadelphia artists contributed to New York exhibitions, or else of dismissing them with few words of comment—often unjustly contemptuous. I propose to reverse this process in the present instance . . . because some of the very best work in this exhibition comes from Philadelphia studios. Whatever differences of opinion there may be with regard to the relative merits and demerits of other performances, it is certain that, considering it simply as a specimen of workmanship, there is not a picture in the display at Kurtz's that is at all up to the high standard of Mr. Thomas Eakins' *William Rush Carving His Allegorical Statue of the Schuylkill.* This represents the interior of Rush's shop, with the artist hard at work putting the finishing touches upon the beautiful statue which all Philadelphians know so well. His model is posing for him, with a large book on her shoulder to aid in enabling her to keep the exact position required, while at her side is an elderly woman engaged in knitting and in preserving the proprieties. The comments made on this picture are curious and amusing. One person objects to the subject; another allows the subject, but thinks that the artist might, with advantage, have treated it in a different manner; a third admits that the workmanship is clever, very clever, but suggests that it lacks refinement; a fourth concedes the refinement, but disputes the color-quality; and so on, and so forth. The substantial fact is that the drawing of the figures in this picture—using the word drawing in its broadest sense to indicate all that goes to the rendering of forms by means of pigments on a flat surface—is exquisitely refined and exquisitely truthful, and it is so admitted by all who do not permit their judgment to be clouded by prejudices and theories about what art might, could, would, or should be were it something else than, in its essence, an interpretation of nature, and of an order of ideas that must find expression through the agency of the facts of nature if they are to find any adequate expression. The best comment on this picture was that made by a leading landscape artist of the old school, and who, being of the old school, certainly had no prejudices in favor of works of this kind. This was that he had not believed there was a man outside of Paris, certainly not one in America, who could do painting of the human figure like this.[96]

Soon after the opening of the Society of American Artists exhibition at the Kurtz Gallery, Eakins was reappointed to his unsalaried post at the Pennsylvania Academy, from which position he was making a reluctant Philadelphia the seat of the most thorough school of the nude in the world. A year later on the death of Professor Schussele, he was made Director of the Schools and his program was soon firmly rooted.

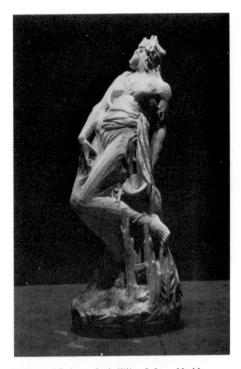

38. Howard Roberts. *Lot's Wife*, 1876–77. Marble, height 40″. Collection of the author. *This dramatic theme is expressed with a baroque vigor unusual in American sculpture of the time. In clay by the Centennial, and in marble a year later, it appeared in 1878 in New York, where it made a sensation at the first exhibition of the Society of American Artists.*

39. *Lot's Wife* at the Society of American Artists exhibition. From *Puck*, March 27, 1878. *Eakins and Roberts, with the Rush painting and Lot's Wife, were the principal exponents of the French academic method in this first exhibition of the Society of American Artists, but the Munich-trained artists dominated the show. Here Frank Duveneck's Apprentice tickles Lot's wife's toes.*

Beaux-Arts on Chestnut Street: Howard Roberts Caps His Career (1876–94)

Behind the single-story marble façade at 1731 Chestnut Street were three rooms. The first one, its ceiling bordered in Oriental characters and sporting an ancient Japanese chandelier, contained Beaux-Arts bric-a-brac, casts, repoussé brass, armor, and Oriental *objets d'art* (*see* frontispiece). Beyond, in file, were sky-lit modeling and cutting rooms. The garden in the rear was lush with shrubbery and flowering plants and alive with a variety of poultry. A correspondent for the *American Register* of Paris, probably Shinn, visited Howard Roberts in this Philadelphia studio in 1879, when Roberts was "still quite a young man, blue-eyed and blond, with rather an English look and air."[97] Another visitor that same year reported:

The studio of Mr. Howard Roberts, on Chestnut Street, is not the boudoir of a Sybarite, but the workshop of an earnest toiler. A visit to it yesterday showed the young but great artist busily at work, in his blouse and with soiled fingers, upon the clay model of a bust of one of those open-handed philanthropists who are the glory of Philadelphia, and whose enduring benefactions project the kindly influences of their lives far forward into the future. With only a small photograph of the deceased, and his own recollections of him, for his guidance, the artist has produced a vivid similitude of the man as he lived and moved amongst his fellows. This model, Mr. Roberts explained, from the plastic character of the material used, could be readily altered from time to time until it suited his conception. The next

step, he said, was to take from the model casts in plaster. This and the chiselling of the bust or statue from the marble are purely mechanical operations, the latter being mainly a matter of exact measurement. The clay model holds all of the sculptor's art. This is called the life. The plaster cast is termed the death, and the completed work in marble or bronze the resurrection.

Mr. Roberts reverently removed the coverings from some of his artistic triumphs. One is a noble statue of Hypatia. . . . Another represents a maiden sitting for the first time for the sculptor. . . . Another is Lot's wife in her saline metamorphosis; her limbs changing to stalactites, and an expression of supreme terror transfixing face and form. Still another represents the infant Napoleon the Great after his first battle with wooden toy soldiers, which lie scattered and broken all about him. Then, in a rear room, there are busts in plaster awaiting a duplication in marble. . . .

The Commonwealth of Pennsylvania is, thus far, unrepresented in that Olympus of America's departed greatness, the Statuary Hall in the National Capitol at Washington. . . . The Keystone State decided about two years ago to be repre-

41. Photograph of Pauline Lewis Roberts, with H. Radclyffe Roberts at six months, October 1877. Collection Dr. H. Radclyffe Roberts, Bryn Mawr. *Apparently the sculptor used his wife as model for* Lot's Wife, *just as he used his infant son for* Napoleon's First Battle, *a studious baby Bonaparte overlooking a field of toy soldiers.*

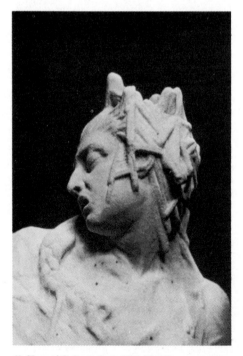

40. Howard Roberts. *Lot's Wife* (detail).

sented in this grand fraternity. . . . The committee awarded the contract for the statue of Robert Fulton to Mr. Roberts, and he will, in a few days, enter upon the welcome work assigned him. It is to be of heroic size. All the details of the plan of the statue are not yet settled by the artist, but the clay model now in his studio exhibits its main conception. . . .

Mr. Roberts is a native Philadelphian. His age is about thirty. Though young, he is already affluent in the honors of his noble art, and richer still in the possibilities before him.[98]

Of the works mentioned in this visit to the artist's studio, two are worth dwelling on, even though they are outside the purview of the immediate subject of the nude in Philadelphia, given the undeserved oblivion into which the sculptor has retreated under recent criticism.

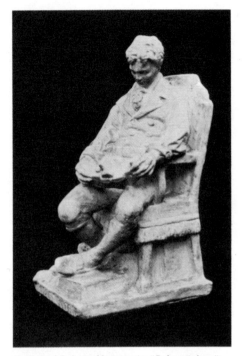

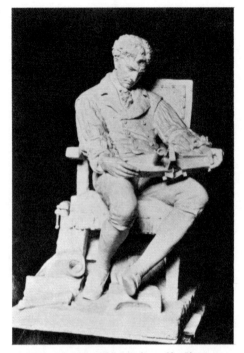

42. Howard Roberts. *Maquette for "Robert Fulton,"* 1879. Plaster, height 11". Collection John Davis Hatch, Lenox, Massachusetts. *The sculptor entered the competition at the last minute with a model in wet clay, of which this is the plaster cast. He won by unanimous acclaim.*

43. Howard Roberts. *Robert Fulton,* 1880. Plaster. Location unknown. Photograph courtesy Dr. H. Radclyffe Roberts, Bryn Mawr. *This photograph of the plaster, destined for the marble cutter, and now lost, makes an unusual record of work in progress when taken with the first maquette (fig. 42) and the finished marble in Washington (fig. 44).*

Hypatia came back to Philadelphia from Paris still in the plaster and was not cut until 1877, when it was put into marble "by a German," who I assume to be Alfred Stauch. With much fanfare it was unveiled at the studio and then put on exhibit at Earle's Galleries. More recent in inception is *Lot's Wife* (fig. 38), which was in the clay during the Centennial, and also cut and unveiled in 1877. This, and not the old *Hypatia,* was the work Roberts chose to represent him at the epoch-making first Society of American Artists exhibition in New York in 1878, to which Eakins sent his *Rush.* "It represents a young lady, on a wild rye whiskey spree, turning into rock-candy," according to *Puck,* which saw it as "an attempt to popularize the *Sun* cure for consumption" (fig. 39). In a different vein, William J. Clark called it a "very

singular creation, which could only have been imagined by the artist in a grotesque mood," but he added a thoughtful valuation in which he places it in the company of Bernini, who certainly influenced it:

It cannot be called beautiful, but it is most original in conception and execution, and, in spite of its grotesqueness, it is full of power and impressiveness. The woman is represented in a writhing attitude, and she is not only being enveloped in the crystals of salt which are forming around her, but she is actually dissolving into salt herself. The idea of transformation is very much more perfectly expressed in this statuette than it is in Bernini's *Daphne,* or in any attempts to represent metamorphosis that we know of. Lot's wife is really turning into a pillar of salt, and, admitting that the idea of such a transformation is a rather queer one for a sculptor to choose, we

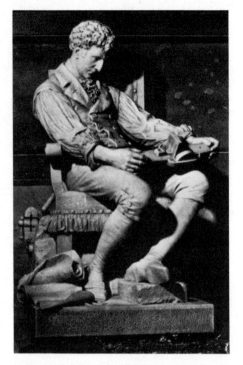

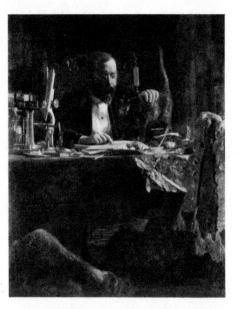

45. Thomas Eakins. *Professor Benjamin Rand, 1874.* Oil on canvas, 60 x 48". Thomas Jefferson University, Philadelphia. *This portrait of a scientist in the routine of his daily work was shown at the Centennial in the same gallery as Roberts's* Première Pose. *The sculptor's* Robert Fulton *follows the same tradition.*

44. Howard Roberts. *Robert Fulton, 1883.* Marble, height 68". The Capitol, Washington, D.C. *This, like Eakins's* Rush, *is based on careful period research and command of anatomy. It crowned a twenty-year career in art.*

must also admit that it is expressed with remarkable skill.[99]

A more immediate stimulus for a theme admittedly rare in American sculpture might have been a work included in the Philadelphia Centennial by Roberts's fellow Sketch Clubber Pierce Francis Connelly, a *Diana Transforming Actaeon.* Having triumphed in the Exposition with a French *académie,* Roberts might well have been moved to try something more Italianate to challenge Connelly, who made a sensation at the Centennial with no less than nine major pieces sent on from Florence. If Roberts was in a grotesque mood he did not otherwise reveal it, and it seems unlikely that he would have any ulterior motives in turning his own wife to salt. In 1876 Howard Roberts had married Pauline Lewis (fig. 41), who certainly was the model.

When the Commonwealth of Pennsylvania first proposed in 1877 to contribute two commemorative statues to the national pantheon in Latrobe's Old House of Representatives, William Clark warned that the provisions were inadequate. "We know of but one thoroughly trained sculptor who is native to this commonwealth—we refer to Mr. Howard Roberts," Clark said, in opposing the rule requiring that all contestants be native Pennsylvanians. He objected also to the proposed compensation of only $15,000 for both, to be delivered to each winner in three installments as work progressed: "It is indeed very doubtful whether life-size marble or bronze statues, such as will be required in this instance, can be had from the hands of a thoroughly qualified sculptor for less than $10,000 apiece."[100] These restrictions made Roberts reluctant to compete, and

65

when entries were gathered at the Academy on November 7, 1878, all were in plaster except the *Fulton* submitted by Roberts, in clay and still wet, "only recently out of the hands of the sculptor who had been induced to compete at the last moment."[101] Roberts won by acclaim, and put his model into plaster (fig. 42). Three months later the correspondent for the *American Register* of Paris (Shinn?), visiting the Beaux-Arts oasis on Chestnut Street, saw the main masses established, but it was a year more before Clark saw it about to be completed in the clay, within a few days of the casting:

> Mr. Roberts has treated his theme with a great deal of originality and power, and we think that all who are at all familiar with works of the class of which it is a representative will agree with us in the opinion that it is in most, if not all, essential particulars by far the finest sitting statue that has been executed by any American sculptor—not excepting Mr. Roberts' own *Premiere Pose*. The peculiar and striking merit of the composition is its absolute unconventionality. The sculptor abandoned heroics at the outset, and endeavored to imagine Fulton, the inventor of the steamboat, in his habit as he lived and engaged in an obviously characteristic occupation.[102]

There are several points of comparison between the *Fulton* and the works of Eakins, Roberts's contemporary in Philadelphia and Paris studios. Roberts studied life portraits of the subject and did research on the casual clothing and workshop accessories of the period, going through a process similar to that Eakins followed in studying for the *Rush* painting, which resulted in a comparable bit of historical genre from the same period in our national development. Like Eakins he brought to bear a mastery of anatomy which gave the figure a credibility that goes beneath the figured vest and ribbed stockings. The concept is similar to the sort of *portrait d'apparat* that Eakins adopted in his *Professor Benjamin Rand* (fig. 45), exhibited at the Centennial in the same gallery as Roberts's sculpture, and to one of Schussele's most famous works, *Men of Progress: American Inventors* (fig. 5). When his *Première Pose* was in plaster, Roberts left it with Alfred Stauch, who procured marble from Carrara and cut it in Gotha, Germany. For the *Fulton* Roberts procured from Carrara a large and flawless marble, probably selected by Stauch, who roughed it out in the Chestnut

Street studio under the daily supervision of the artist. Roberts himself put on the finishing touches and cut the face. Although the Italian marble was cut by a German after a model made by an artist trained in France, the press commended Roberts for his patriotic determination to execute the work in his American studio, and the *Fulton* was acclaimed an American masterpiece. After a preview in the Chestnut Street studio on February 18, 1883, Roberts prepared to transport the finished *Fulton* and its pedestal to Washington. Three years after it was put in plaster it was installed in the Capitol (fig. 44) on February 26, 1883, and was praised for its originality, technical excellence, naturalness of attitude, and force of expression. It seems appropriate that it came to rest in the Old House of Representatives designed by Latrobe, who once had rescued from disaster the plans of John Dorsey for the original Pennsylvania Academy.

In 1894 Howard Roberts closed the studio at 1731 Chestnut Street, the scene of triumphant previews for twenty years, and gave the residual contents to the School of Industrial Art. He wrote to Harrison S. Morris, then secretary of the Pennsylvania Academy of the Fine Arts, on February 22, 1894:

> I have a large life size marble figure, entitled "Hypatia," executed by me several years ago, which has never been on exhibition except a short time at Earle's Galleries.
>
> I should like to offer the statue as a loan to the Academy if it meets your approval, and also of the Board of Directors.
>
> I have also my life size nude figure in marble, entitled "La Premiere Pose" which took a medal at the Centennial. This statue I propose taking with me to Europe, but it would give me great pleasure to exhibit it in your Academy before I leave my home for an indefinite time.[103]

Epilogue: Rounding Out a Century (1795–1895)

Lorado Taft regarded Roberts's career as meteoric, which may be justifiable for an active professional life spanning thirty years, in that the work which put him squarely in the vanguard of American sculpture was begun when he was thirty, but ten years later the same skill and approach as applied to the work that capped his career could be considered *retardataire*. Taft saw the change in American sculp-

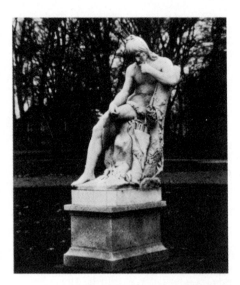

46. Augustus Saint-Gaudens (born Dublin 1848; died
Cornish, New Hampshire, 1907). *Hiawatha*, 1870–74.
Marble. Location unknown. Photograph courtesy
Dartmouth College Library, Hanover, New Hampshire.
*Saint-Gaudens joined Eakins and Roberts in 1868 at
the Ecole des Beaux-Arts, where they had friends in
common. With this* académie *he parallels their
contemporaneous efforts with American subject matter
and mastery of the figure.*

47. Saint-Gauden's *Diana*
in progress in the sculp-
tor's studio, about 1891.
Photograph courtesy
Dartmouth College
Library, Hanover, New
Hampshire. *In the
vanguard of American
sculpture in 1876,
Roberts's development
arrested where it was,
while Saint-Gaudens
carried on from that
point. The simple lines
and elongation of the
figure were dictated by
the intended site atop the
first Madison Square
Garden, but are the result
of the total "possession"
of anatomy acquired in
Paris. Less than a century
after Wertmüller arrived
with America's first
distinguished exhibition
nude, which had to be
exhibited separately to
ladies and gentlemen,
this graceful figure was
raised up for millions to
admire in the open air
in 1892.*

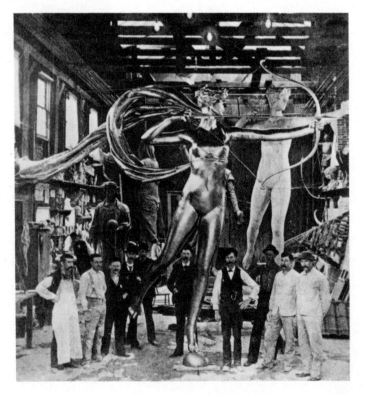

ture that was ushered in at the Centennial as being a shift from the Italian Neoclassicism of Story and Powers to Saint-Gaudens's French Beaux-Arts command of the art motif. Before achieving the refinement of his *Diana*, Saint-Gaudens had to pass through the same hard routine as Roberts at the Ecole des Beaux-Arts, and was in Rome working on his own exhibition nude, a *Hiawatha* (fig. 46), while Roberts was in Paris preparing his for the Centennial. Saint-Gaudens's development did not depend upon Roberts's example, but upon the same source, then new to American sculpture. But at that moment Roberts's level of achievements within the stiff requirements of the *académie* was the more advanced, and his *Première Pose* was celebrated at the Centennial as a triumphant breakthrough.

Roberts possessed both the manners and social status prerequisite for immediate patronage in Philadelphia. Lacking both, his colleague Eakins went unnoticed by collectors at the outset of his career and was ignored later. His power of intellect and ability as a teacher gave him the respect and support of the academic community, his most advanced colleagues, and the city's serious art students. They put him into the new Pennsylvania Academy in 1876, and forced the management to reverse itself on his exclusion from the studios in 1877–78, after which Eakins made the school the most thorough school of the nude in the world. Given Philadelphia's abiding prejudice against life classes and other means of studying human anatomy, it was only a question of time before his professional rivals, mostly old students, were able to use this leverage to pry him from his post, and in 1886 his resignation was requested. In 1895, a century after the bashful baker fled the model stand before Peal's Columbianum life class, Drexel Institute abruptly canceled Eakins's course in anatomy when, in a carefully preannounced lecture on the pelvic region delivered before a mixed class, he had made a male model pose in the "ensemble."

Cable advices from Paris announce the death in that city of Howard Roberts, the American sculptor.

Mr. Roberts was a son of Edward Roberts, and was born in Philadelphia on April 8, 1843. He began his artistic studies under the late Joseph A. Bailly at the Academy of the Fine Arts in this city. In 1866 he went to Paris, where he studied at the Ecole des Beaux Arts and also under Dumont and Gumery. On returning to this city he opened a studio here, the first notable work he produced being the statuette of "Hester Prynne."

The following year Mr. Roberts returned to Paris, where he remained several years, and while there modeled "La Premiere Pose," which received a medal at the Centennial Exposition of 1876. He was married in June, 1876, to Miss Helen Pauline Lewis, of this city, who, with a son now in Paris, survives him.[104]

INTRENT. REDEANTQ. FOELICES. This inscription, "Enter and You Will Be Happy," is on the entablature of a Renaissance doorway in the Philadelphia Museum of Art. The room was given in 1928 in memory of Howard Roberts by members of his family.[105] Upon his departure for France, the *Hypatia* and *Première Pose* remained on deposit at the Pennsylvania Academy of the Fine Arts. In 1928 the sculptor's widow presented the former to the Academy, and in 1929 gave to the Museum the *Première Pose*. That same year Thomas Eakins's widow and Miss Mary A. Williams gave the Museum *William Rush Carving His Allegorical Figure of the Schuylkill River*. Thus these kindred works by fellow students in the old Pennsylvania Academy and the Ecole des Beaux-Arts of the last years of the Second Empire can be seen within the same walls today, along with the bronze taken from the pioneer figure work by Rush, which Eakins celebrated in his painting, and the *Diana* of 1892 by Saint-Gaudens (fig. 47), which grew out of the art tradition that they both represent.

Notes

1. Quoted in William Dunlap, *History of the Rise and Progress of the Arts of Design in the United States* (New York: George P. Scott and Co., 1834), vol. 1, pp. 318–19.

2. "A History of The Columbianum or American Academy," anonymous manuscript written after 1833, preserved in a typescript of 1945, Pennsylvania Academy of the Fine Arts, Philadelphia (hereafter called PAFA) Archives.

3. Minutes of the Columbianum are bound in "Papers Relating to the Early History, Academy of Fine Arts of Phila., Peale, 1794–5," Historical Society of Pennsylvania, Philadelphia.

4. Charles Coleman Sellers, *Charles Willson Peale* (Philadelphia: The American Philosophical Society, 1947), vol. 2, p. 71.

5. E[arl] S[hinn], "The First American Art Academy, First Paper," *Lippincott's Magazine*, vol. 9 (February 1872), p. 145.

6. Quoted in Sellers, *Peale*, vol. 2, p. 72.

7. Charles Willson Peale to Thomas Jefferson, June 13, 1805, in "Extracts from the Correspondence of Charles Wilson [*sic*] Peale Relative to the Establishment of the Academy of the Fine Arts, Philadelphia," *The Pennsylvania Magazine of History and Biography*, vol. 9, no. 2 (1885), p. 122.

8. *Aurora*, June 23, 1812.

9. Frances Trollope, *Domestic Manners of the Americans*, ed. Donald Smalley (New York: Alfred A. Knopf, 1949), pp. 268–69.

10. Communication from the Council of Academicians, January 13, 1813, signed by William Rush, Thomas Sully, Rembrandt Peale, and Gideon Fairman, PAFA Archives. For additional information, *see* Edward J. Nygren, "The First Art Schools at the Pennsylvania Academy of the Fine Arts," *The Pennsylvania Magazine of History and Biography*, vol. 95, no. 2 (April 1971), pp. 221–38; and David Sellin, "Denis A. Volozan, Philadelphia Neoclassicist," *Winterthur Portfolio 4* (1968), pp. 119–28.

11. "An artist of Philadelphia," quoted in Dunlap, *History*, vol. 1, p. 424.

12. *Ibid.*, p. 422.

13. Quoted in E[arl] S[hinn], "The First American Art Academy, Second Paper," *Lippincott's Magazine*, vol. 9 (March 1872), pp. 312–13.

14. Trollope, *Domestic Manners*, p. 326.

15. Rembrandt Peale, "Reminiscences: Adolph-Ulric Wertmüller," *The Crayon*, vol. 2, no. 14 (October 3, 1855); reprinted in Michel Benisovich, "The Sale of the Studio of Adolph-Ulrich Wertmüller," *The Art Quarterly*, vol. 16, no. 1 (Spring 1953), p. 37.

16. Report of the Society of Artists, April 1812, in Anna Wells Rutledge, ed., *Cumulative Record of Exhibition Catalogues: The Pennsylvania Academy of the Fine Arts, 1807–1870; The Society of Artists, 1800–1814; The Artists' Fund Society, 1835–1845* (Philadelphia: The American Philosophical Society, 1955), p. 2.

17. Rembrandt Peale, "Reminiscences," in Benisovich, "The Sale of the Studio," p. 38.

18. Dunlap, *History*, vol. 1, pp. 417–18.

19. *Port Folio* (January 1814), quoted in Benisovich, "The Sale of the Studio," pp. 33–34.

20. Rembrandt Peale, "Reminiscences," in Benisovich, "The Sale of the Studio," pp. 38–39.

21. *Proceedings of the Annual Meeting of the Stockholders, Pennsylvania Academy of the Fine Arts, June 4, 1855* (Philadelphia: T. K. and P. G. Collens, 1855), p. 10.

22. Signoret or Mallard in New Orleans, where he first stayed in this country, or with Quervelle in Philadelphia or Roux in New York.

23. John Sartain, *The Reminiscences of a Very Old Man, 1808–1897* (New York: D. Appleton and Company, 1899), pp. 250–51.

24. Sigma [Earl Shinn], "A Philadelphia Art School," *The Art Amateur*, vol. 10 (January 1884), p. 32.

25. Memoirs of William Sartain, 1904, p. 69, Philadelphia Museum of Art Archives.

26. Thomas Eakins to the Committee on Instruction, dated January 8, 1876 (but Committee minutes show this to be January 8, 1877), PAFA Archives.

27. Edwin Austin Abbey, quoted in E. V. Lucas, *Edwin Austin Abbey, Royal Academician: The Record of His Life and Work* (New York: Charles Scribner's Sons, 1921), vol. 1, p. 13.

28. Willard P. Snyder, quoted in *ibid.*, vol. 1, p. 11.

29. S[hinn], "First American Art Academy, Second Paper," p. 320.

30. William J. Clark, Jr., *Great American Sculptures* (Philadelphia: George Barrie, 1879), p. 105.

31. Sigma [Shinn], "A Philadelphia Art School," p. 32.

32. Minutes of the Philadelphia Sketch Club, November 26, 1861.

33. *Evening Telegraph,* March 12, 1878.

34. Later, John Bigelow was a fellow passenger on Eakins's second Atlantic crossing in Winter 1869.

35. Albert Lenoir to Thomas Eakins, September 11, 1866, transcribed in French by Eakins into his account book, Philadelphia Museum of Art, 49-84-1 (author's translation).

36. Philadelphians in Paris about this time included Sketch Clubbers Howard Helmick, Augustus Heaton, Robert Wylie, Pierce Francis Connelly, Daniel R. Knight, Harry Bispham, and Thomas Moran, who was there for the 1867 Exposition, as was William T. Richards. Also in Paris were Mary Cassatt and Eliza Haldeman, who as women were not admitted to the Ecole.

37. Thomas Eakins to John Sartain, October 29, 1866, PAFA Archives.

38. Edward Strahan [Earl Shinn], "Frederick A. Bridgman," *Harper's New Monthly Magazine,* vol. 63 (October 1881), p. 695.

39. Charles Fussell to Thomas Eakins, December 18, 1866, Hirshhorn Museum and Sculpture Garden, Washington, D.C. This is the letter in which Fussell sketched the life class at the Academy (fig. 7).

40. Philip Gilbert Hamerton, "The Artistic Spirit," in *Thoughts About Art,* new ed., rev. (London: Macmillan and Co., 1873), p. 196.

41. *The New York Times,* February 21, 1886.

42. Interview with Claude Monet, 1900, in Linda Nochlin, ed., *Impressionism and Post-Impressionism, 1874–1904, Sources and Documents* (Englewood Cliffs, N.J.: Prentice-Hall, 1966), p. 40.

43. Jean-Léon Gérôme, quoted by J. Alden Weir, his student, in a letter of July 5, 1875, in Dorothy Weir Young, *The Life and Letters of J. Alden Weir* (New Haven: Yale University Press, 1960), p. 79.

44. Letter of Thomas Eakins, quoted in Lloyd Goodrich, *Thomas Eakins: His Life and Work* (New York: Whitney Museum of American Art, 1933), p. 20.

45. Edward Strahan [Earl Shinn], *The Masterpieces of the Centennial International Exhibition, Volume I: Fine Art* (Philadelphia: Gebbie & Barrie, 1876–77), p. 126.

46. *Ibid.,* pp. 215–16.

47. "Philadelphia Sculpture," *Evening Bulletin,* 1870. Undated newspaper clipping in a scrapbook in the collection of Dr. H. Radclyffe Roberts (hereafter referred to as Roberts Scrapbook). The newspaper clippings in the scrapbook are frequently accompanied by handwritten dates and newspaper designations. Where possible, missing dates have been supplied by context.

48. *Evening Telegraph,* April 2, 1870 (Roberts Scrapbook).

49. *Evening Bulletin,* Summer 1870 (Roberts Scrapbook). Miss McK—— is elsewhere identified as a young relative of a "Philadelphia lady." This bust was cut in marble in reduced size and exhibited in Caldwell's window.

50. *Evening Telegraph,* 1873 (Roberts Scrapbook).

51. *Evening Telegraph,* 1873 (Roberts Scrapbook).

52. Willard Meyers, "History of the Philadelphia Sketch Club," typescript, Philadelphia Sketch Club Archives.

53. Minutes of the Philadelphia Sketch Club, March 6, 1873, and May 13, 1873.

54. Unidentified press clipping after March 6, 1873 (Roberts Scrapbook).

55. The *Philadelphia Sketch Club Portfolio* was sent off on May 21, 1874.

56. Undated *New York Herald* clipping by the regular Paris correspondent initialed W. H. H. (Roberts Scrapbook).

57. *New York Herald,* datelined Paris, April 20, 1874 (Roberts Scrapbook).

58. Undated *New York Herald* clipping, Paris correspondent (Roberts Scrapbook).

59. Strahan [Shinn], *Masterpieces,* p. 126.

60. Quoted in an undated clipping from the *Star* (Roberts Scrapbook).

61. "An Hour in a Sculptor's Studio," *Progress,* January 18, 1879 (Roberts Scrapbook).

62. "Address to the Artists of the United States," reprinted in *Report of the Director-General, including the Reports of Bureaus of Administration, United States Centennial Commission, International Exhibition, 1876* (Philadelphia: J. B. Lippincott & Co., 1879), vol. 1, pp. 148–49.

63. Thomas Eakins to Earl Shinn, April 13, 1875, Cadbury Collection, Friends Historical Library, Swarthmore College, Swarthmore, Pennsylvania.

64. John Sartain to Emily Sartain, August 1875, Sartain Papers, Historical Society of Pennsylvania, Philadelphia.

65. *Sunday Press*, January 1876 (Roberts Scrapbook).

66. Geo. M. Robeson, Secretary of the Navy, to the Honorable Z. Chandler, Secretary of the Interior, February 15, 1876, in *Report of the Director-General*, vol. 1, p. 156.

67. *Evening Bulletin*, February (?) 1876 (Roberts Scrapbook).

68. *Evening Telegraph*, February 21, 1876. The *Press* and *Bulletin* also gave good reviews.

69. John Sartain to Thomas Moran, March 6, 1876, Sartain Papers, Letter Press Book, 1875–76, Historical Society of Pennsylvania, Philadelphia.

70. G. W. Sheldon, *American Painters*, enlarged ed. (New York: D. Appleton and Company, 1881), p. 100.

71. John Sartain to Charles Perkins, March 24, 1876, Sartain Papers, Letter Press Book, 1875–76, Historical Society of Pennsylvania, Philadelphia.

72. *New York Daily Tribune*, June 1, 1876.

73. Clark, *Great American Sculptures*, pp. 100–101.

74. Lorado Taft, *The History of American Sculpture*, new ed., rev. (New York: Macmillan Company, 1924), pp. 256–58.

75. John Sartain, *Reminiscences*, p. 252.

76. [Earl Shinn], "Fine Arts: The Pennsylvania Academy," *The Nation*, vol. 22 (May 4, 1876), pp. 297–98.

77. Sigma [Shinn], "A Philadelphia Art School," p. 33.

78. *Evening Bulletin*, April 28, 1871; *Philadelphia Inquirer*, April 27, 1871.

79. Thomas Eakins to Earl Shinn, January 20, 1875, Cadbury Collection, Friends Historical Library, Swarthmore College, Swarthmore, Pennsylvania.

80. Thomas Eakins to Earl Shinn, April 2, 1874, Cadbury Collection, Friends Historical Library, Swarthmore College, Swarthmore, Pennsylvania.

81. Sigma [Shinn], "A Philadelphia Art School," p. 32.

82. Thomas Eakins to Earl Shinn, April 13, 1875, Cadbury Collection, Friends Historical Library, Swarthmore College, Swarthmore, Pennsylvania.

83. *Evening Telegraph*, February 21, 1876.

84. "Petition" to the Board of Directors, January 22, 1876, PAFA Archives. Howard Roberts had just been elected president of the Sketch Club. The petition is in Clark's hand, and his was the first signature, followed by Eakins's.

85. Minutes of the Board of Directors, December 13, 1875, PAFA.

86. Report of the Committee on Instruction, Minutes of the Board of Trustees, October 9, 1876, PAFA Archives.

87. Minutes of the Committee on Instruction, January 9, 1877, PAFA Archives.

88. Harrison S. Morris, *Confessions in Art* (New York: Sears Publishing Company, 1930), pp. 36–37.

89. Minutes of the Board of Directors, September 9, 1878, PAFA.

90. J[ames] S. W[hitney], "Art?," *The Penn Monthly*, vol. 8 (May 1877), pp. 369–70.

91. Christian Schussele to the Committee on Instruction, June 1877, PAFA Archives.

92. Léon Bonnat, quoted in G. W. Sheldon, "American Painters.—William Sartain," *The Art Journal*, vol. 6 (June 1880), p. 162; reprinted in Sheldon, *American Painters*, p. 200.

93. *See* note 44.

94. A sketch of the leg of Rush's *Washington* is scribbled on the letter from Thomas Eakins to Earl Shinn dated April 13, 1875, Cadbury Collection, Friends Historical Library, Swarthmore College, Swarthmore, Pennsylvania.

95. [Earl Shinn], "Fine Arts: The Lessons of a Late Exhibition," *The Nation*, vol. 26 (April 11, 1878), p. 251.

96. *Evening Telegraph,* March 12, 1878.

97. *American Register* (Paris), February 22, 1879 (Roberts Scrapbook).

98. *Progress,* January 18, 1879 (Roberts Scrapbook).

99. Clark, *Great American Sculptures,* p. 103.

100. *Evening Telegraph,* January 24, 1877.

101. *Daily Times,* November 8, 1878 (Roberts Scrapbook).

102. *Evening Telegraph,* March 25, 1880 (Roberts Scrapbook).

103. Howard Roberts to Harrison S. Morris, February 22, 1894, PAFA Archives.

104. *Philadelphia Press,* April 20, 1900.

105. Designated the "Howard Roberts Memorial." Two doorways and the ceiling of what is called the "Florentine Room" were given by the following members of Howard Roberts's family: Mrs. Timothee Adamowski, Sr., Mrs. Samuel Bell, Jr., Mrs. Edward Browning, Edward Browning, Mrs. John C. Groome, Mr. and Mrs. W. Barklie Henry, Mrs. Arthur V. Meigs, Clarence Lewis Roberts, Mrs. Edward Roberts, Edward Roberts, Mrs. Howard Roberts, Howard Radclyffe Roberts, Mrs. J. R. Evans Roberts, Paul Roberts, and William Twells Tiers.

About the Author

David Sellin, a native Philadelphian, received his Ph.D. in art history from the University of Pennsylvania. He studied painting with F. B. A. Linton, a student of both Eakins and Gérôme, and at the Royal Academy of Stockholm. Formerly Assistant Curator of Painting and Sculpture at the Philadelphia Museum of Art and head of the schools at the Pennsylvania Academy of the Fine Arts, Dr. Sellin has served on the art-history faculties of Colgate, Wesleyan, and Tulane universities.

Photographs by A. J. Wyatt (staff photographer), nos. 8, 9, 31, 34, 45; Brenwasser, courtesy M. Knoedler & Co., no. 7; Chappel Studio, no. 2; Bernie Cleff, cover, nos. 20, 21, 24, 25, 26, 27, 28, 29, 38, 40; Phillips Studio, nos. 4, 10.

Designed by John Anderson

Printed by The Falcon Press